THE CATHOLIC
UNIVERSITY OF AMERICA

ROBERT P. MALESKY

The Campus History Series

THE CATHOLIC
UNIVERSITY OF AMERICA

ROBERT P. MALESKY

ARCADIA
PUBLISHING

Published by Arcadia Publishing
Charleston SC, Chicago IL, Portsmouth NH, San Francisco CA

Printed in the United States of America

Library of Congress Catalog Card Number: 2009937159

For all general information contact Arcadia Publishing at:
Telephone 843-853-2070
Fax 843-853-0044
E-mail sales@arcadiapublishing.com
For customer service and orders:
Toll-Free 1-888-313-2665

Visit us on the Internet at www.arcadiapublishing.com

*To my wife (and proofreader), Kee, another CUA graduate.
We met in Albert Hall and have been together since, for
which I am eternally thankful.*

CONTENTS

ACKNOWLEDGMENTS

Everyone with whom I have had contact at Catholic University has been extraordinarily cooperative and helpful, beginning with provost Dr. James Brennan and Victor Nakas, associate vice president for public affairs, who read every word of copy and examined every photograph throughout the book's evolution.

This project would not have been possible at all without the gracious assistance of the American Catholic History Research Center and University Archives, including chief archivist Timothy Meagher and his staff—Leslie Knoblauch, Maria Mazzenga, W. John Shepherd, Jane Stoeffler, and most especially audio-visual archivist Robin Pike, whose diligence, persistence, and good humor were invaluable to me for the months we worked together.

There were many others from around the country who aided me, including Rev. Clyde Crews, historian of the Louisville Archiocese; Dr. William E. Klingshirn of CUA's department of Greek and Latin; Dr. Geraldine Rohling, archivist of the Basilica of the National Shrine of the Immaculate Conception; Justine Garbarino, former editor of the *Tower* newspaper; Rev. Philip Gage of the Marist Center; Sr. Judith Salekova, archivist of the Peoria Diocese; Dr. Monica J. Blanchard, curator of CUA's Semitics/Institute of Christian Oriental Research Collections; David McGonagle, director of the CUA Press; and John Feeley of St. Anthony of Padua Catholic Church in Brookland. My sincere thanks to all.

Finally, thanks to my editors at Arcadia Publishing, including Elizabeth Bray, Maggie Bullwinkel, and Brooksi Hudson.

All photographs are from the American Catholic History Research Center and University Archives unless otherwise noted.

INTRODUCTION

Telling a history through photographs can be both daunting and rewarding. Daunting because one simply cannot give as full a story as with a traditional narrative history, and much nuance will by necessity be lost. Rewarding because a photographic history can do something a traditional one cannot: it shows us real people and places rather than just presenting words about them. The struggle in this book has been to find the right balance between the two—to give enough detail to provide context and a sense of history, yet allow the pictures to tell as much of the story as possible and to give a sense of humanity to the people described.

Of course, some of the history of a great institution such as Catholic University simply cannot be transmitted via pictures. The complex philosophical and theological debates that led to the formation of the university cannot be seen in the photograph of the Third Plenary Council, and so much of that crucial discussion will not be found here. On the other hand, a traditional text might not show the care and worry felt by Bishop John Keane, the first rector of the university, when difficulties piled up during the early years of the school. But it can be seen in his face if one knows to look for it.

This book, then, is the story of the place and its people, as seen through the camera lens. The great majority of the images are from the American Catholic History Research Center and University Archives, with additional material from the Library of Congress and other sources. They tell of the sense of anticipation and joy when the school first opened and the difficulties, financial and otherwise, that quickly ensued. They show how the campus grew from a bucolic estate on the outer fringes of the nation's capital to a thriving, urban center of learning and research. They depict students buckled down in study but also cutting loose and having fun. They illustrate the famous and the not so famous, the wealthy patrons and those who struggled to succeed, the sacred and the secular.

Despite the ecclesiastical roots of the university, not all the people involved in its foundation and growth were saints, nor certainly were they all sinners. Like any institution developed by men and women, flaws emerge and are dealt with, sometimes successfully, sometimes not. The founders of the school displayed true nobility of spirit, though it was occasionally tainted by pettiness or ego. The point is they were not caricatures or whitewashed portraits of religious righteousness but flesh and blood human beings, which makes their accomplishments all the more noteworthy. This book tries to show them in that light but always with respect and even admiration for what they were attempting to do, sometimes against enormous odds.

The Catholic University of America did not develop slowly over time, as had many older schools. It did not start out as a log-cabin college that blossomed into a university over the centuries. It was born whole cloth as a university—as the national university of the Catholic Church—and as such, it had a certain grandness built into its foundation, even if all the resources were not there at the beginning to match the vision. Catholic University was conceived as a graduate institution for men only. How it evolved into a coeducational school that also accepted undergraduates is part of the story portrayed here.

This book takes a close look at the architectural history of the university; how the campus grew and evolved; and how the original academic Gothic style was affected by the construction of the National Shrine of the Immaculate Conception, once a part of the university but eventually separating into an independent institution. Many of the early buildings are now gone, mostly victims of age, but their legacy and their visual impact is preserved in the images on these pages. A trip down Michigan Avenue early in the 20th century was a tour of varied architectural approaches—collegiate Gothic next to Flemish next to Italianate—yet somehow they all felt part of one university.

This is also the story of the neighborhood across the tracks, originally the estate of Jehiel Brooks, veteran of the war of 1812 and noted local curmudgeon. The Catholic University of America and Brookland were born at the same time and grew together, one inseparably entwined with the other. The school's presence in the northeast quadrant of the city drew people like Antoinette Margot, a late convert to Catholicism who worked with priests at Catholic University to establish a parish in Brookland. The university acted like a magnet, attracting not just individuals but Catholic institutions by the hundreds, who sprinkled themselves throughout the area, giving Brookland the nickname "Little Rome." Religion, politics, and race all played a role in the school's relationship with the neighborhood and all changed over time.

The Catholic University of America came of age after World War I. A new gymnasium and stadium symbolized a different attitude toward sports and some of the non-religious aspects of campus life, while a new library and chemical laboratory reemphasized the school's dedication to scholarship and research. Challenges that faced the country also faced the university—the role of women, the integration of the races, spirituality, and secularism. There were many successes and some failures, but throughout it all, the school continued to grow and thrive.

Although the main focus of the book is on 19th- and 20th-century photographs and events, the final chapter does bring us into the 21st century. As the university faces the future, new buildings have arisen, new students have made the school theirs, and new people have come to visit, including Pope Benedict XVI in 2008. Enjoy this photographic tour of Catholic University, keeping in mind that pictures tell only part of the story and remembering that there are plenty of resources available for more information.

One

FOUNDING

The idea first appeared around 1810 but really began to percolate right after the end of the Civil War. What about a national Catholic university in the United States? It was an idea that had struck Bishop Martin J. Spalding of Louisville in the 1850s but gained full flower once he was named archbishop of Baltimore in June 1864. He gathered the country's bishops in a plenary council in 1866 and, among many other items discussed, raised the idea of a national Catholic university. It generated some interest, but the time was not yet right.

The conversation was continued over the next years, particularly by Archbishop Spalding's nephew, Rev. John Lancaster Spalding. He took a dim view of the state of Catholic education in America, finding "a deplorable dearth of intellectual men. . . . We have no university—no central seat of learning encircled by the halo of great names, to which the eyes of Catholics from every part of the land might turn with pride and reverence. The passion for learning and literary excellence, like the other passions, grows by contact with that which stimulates it. Many a mute, inglorious Milton dies unwept, unhonored and unsung, because he had never felt the magnetic influence of a living mind, enamored of high excellence."

There were seminaries and Catholic colleges in the country, but there was not yet a place like the University of Louvain in Belgium, which focused on what we now call graduate studies—professional schools with an emphasis on research. That is what John Lancaster Spalding and his like-minded peers continued to push, write, and evangelize for. Finally the matter was scheduled to be discussed again by the country's bishops at the Third Plenary Council, set for 1884.

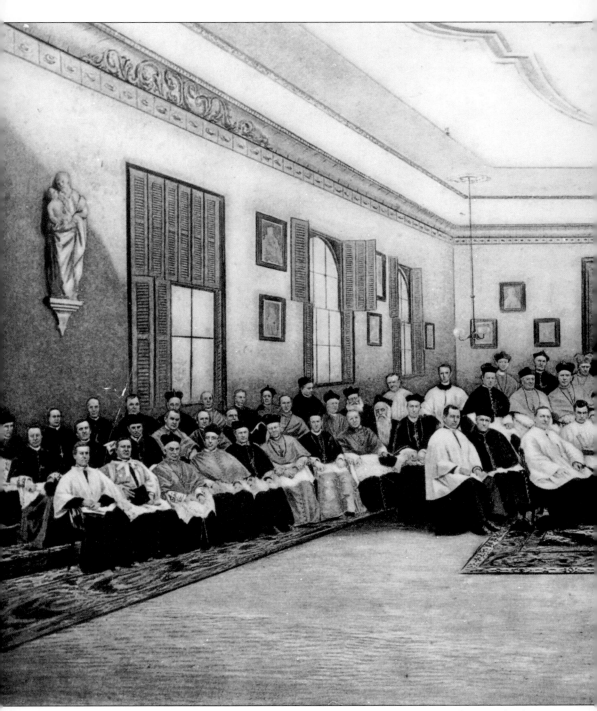

The Third Plenary Council of Baltimore met at St. Mary's Seminary during the last two months of 1884. In the center is Archbishop James Gibbons, who led the council after being appointed apostolic delegate by Pope Leo XIII. In the second row on the left, beneath the first window, is Bishop John J. Keane, who would serve as the university's first rector. There

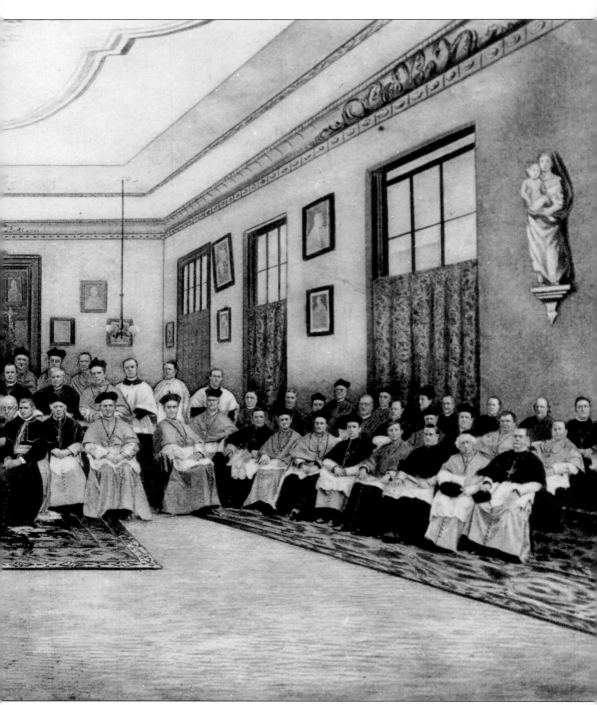

was considerable discussion about whether a university was called for or if a seminary for advanced study would be more useful. The deciding factor was a $300,000 gift provided to the council by heiress Mary Gwendolen Caldwell "for the purpose of founding a National Catholic School of Philosophy and Theology." The Catholic University of America was born.

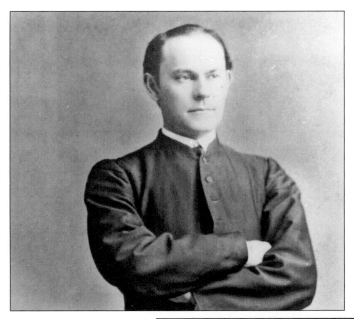

This photograph of the Most Reverend John Lancaster Spalding is from 1878, two years after he was appointed bishop of Peoria by Pope Pius IX. Spalding was a young, dynamic writer and speaker with a particular passion for education. He is credited with leading the intellectual charge for a national Catholic university, and it was his close friendship with Mary Gwendolen Caldwell that secured initial funding for its establishment.

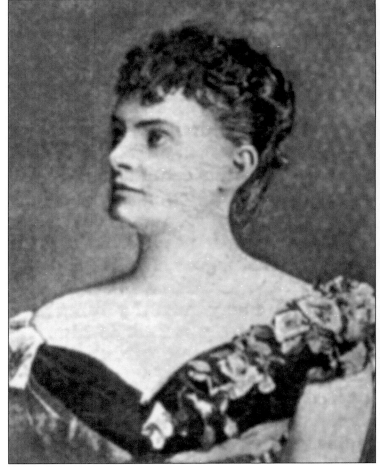

From a rare 1889 photograph, this is Mary Gwendolen Caldwell. The daughter of a wealthy Louisville businessman who converted to Catholicism late in his life, Mary Gwendolen (known as Mamie) first met Bishop Spalding when he was the chaplain at her school, the Sacred Heart Academy in New York City. Born in 1863, she was only 21 years old when she pledged her contribution to the Third Plenary Council.

Whereas Miss Mary Gwendolin Caldwell
of New York having made an offer to the
Fathers of the III Plen. Coun. of Balt. in Nov.
last, an offer of $300,000. for the purpose of
founding a Theological Seminary for the higher
education of the C. Clergy of the U.S. said Sem-
inary to form the basis of a future Cath. Univ.
the offer having been made under the certain con-
ditions vz= 1° that Miss Caldwell be always con-
sidered the founder of the new institution; 2° that
said institution be not under the charge of any

Of course, Mary Gwendolen Caldwell did not make her contribution without conditions. This is a page of handwritten minutes from an 1885 board of trustees meeting that outlines those terms, which numbered eight: that Mary Gwendolen Caldwell always be considered the founder of the school; that it is never to be under the control of any individual religious order; that the school be established in the United States; that it is to be under the control of a committee of bishops; that it is to be a separate institution, not affiliated with any other institution; that only ecclesiastics who had completed elementary courses in philosophy and theology can be accepted; that other faculties may be affiliated with it in order to form a Catholic university; and that the money given will never be diverted and the site, once chosen, will not be changed.

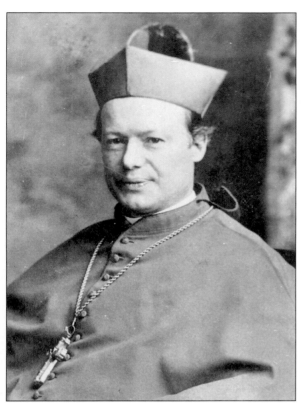

Even after the Third Plenary Council voted to approve the creation of a Catholic university, opposition remained strong and sometimes vehement. Archbishop Michael Corrigan of New York (to the left) and Bishop Bernard McQuaid of Rochester (below) were good friends and two of the leading opponents of the university project. The objections centered on location (Washington was too far south, it was politically corrupt, and there were not enough Catholics there), competition with other Catholic institutions (primarily Georgetown College), and finances (American Catholics were willing to fund churches and charities, less so when it came to educational institutions). There were also arguments about the purpose of a Catholic university, with some feeling that diocesan seminaries needed to be established before a national university should be considered.

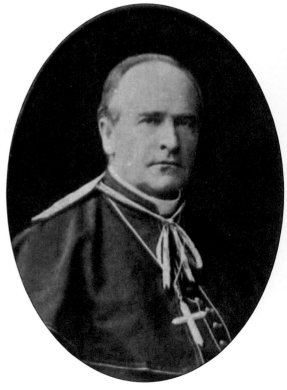

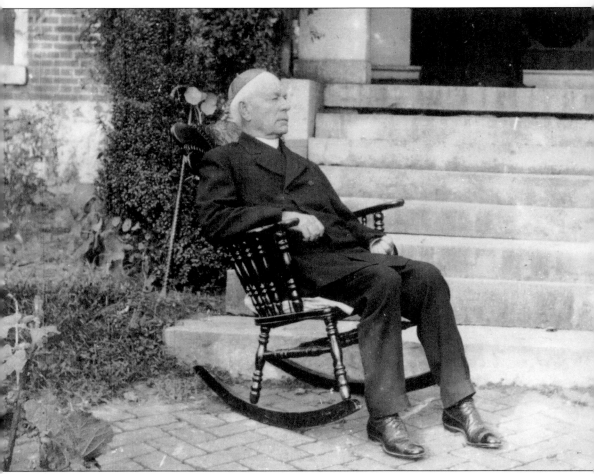

Bishop John Lancaster Spalding, shown here later in life, had some answers to the dissidents' arguments: location—if it was to be a national university it should be in the nation's capital; other institutions—Georgetown and similar schools served undergraduates and professionals, while the new university was to be a graduate institution; and finances—to which he responded, "Money is necessary, and this, I am persuaded, we may have. A noble cause will find or make generous hearts." Spalding was offered the first rectorship of Catholic University but declined, as he would decline future postings that would take him away from his home base of Peoria. The choice fell instead on the Most Reverend John J. Keane, the bishop of Richmond. Keane had been selected to the board of trustees in 1885 and was one of the four bishops entrusted with raising funds for the new university, but he had no inkling that he might be its first leader.

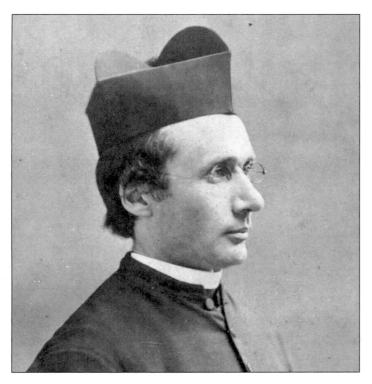

Rev. John J. Keane, shown here as a young priest, was born in County Donegal in Ireland. He immigrated to the United States with his family in 1846. Ordained 20 years later, he was made curate of St. Patrick's in downtown Washington, D.C., where he served until 1878, when he was consecrated bishop of Richmond. He replaced the Most Reverend James Gibbons, who had been appointed archbishop of Baltimore.

Archbishop James Gibbons is seen here in an 1884 photograph. When the post of rector had been offered to Bishop Keane, he at first demurred, telling Archbishop Gibbons that he assumed it would go to Bishop Spalding, and "adding my profound conviction that I was utterly unfit, by education and by inclination, to be at the head of a house of study and, still more, to organize a University."

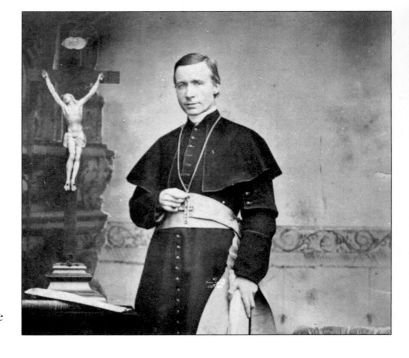

Despite Bishop Keane's own misgivings, Archbishop Gibbons felt that with Bishop Spalding no longer in consideration for the rectorship, Keane was the only man for the job; the whole project might fall through without him. Keane then gave his consent, which had to be approved by the Pope.

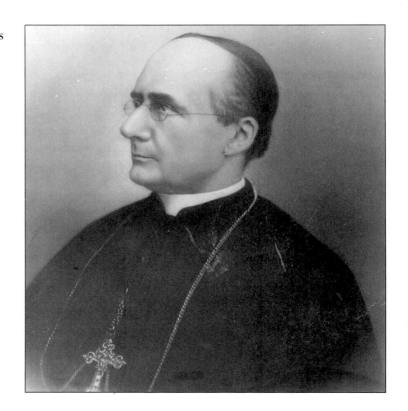

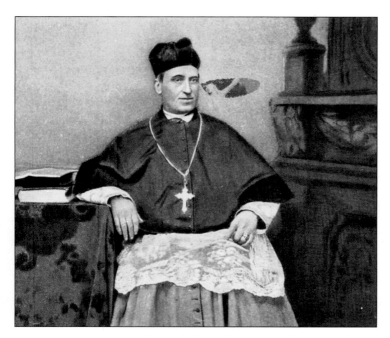

After the selection of bishop Keane as rector, the Bishops' committee on the university asked Keane and the Most Reverend John Ireland (to the left), bishop of St. Paul, to present letters to the Vatican in Rome outlining the plan for the university. If successful, this would represent the formal approval of the university. If unsuccessful, the idea of a national Catholic university would be delayed for years if not killed altogether.

17

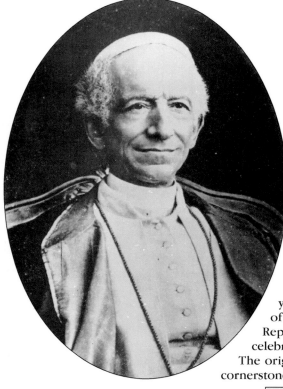

Pope Leo XIII was a careful man. He was aware of the objections of some bishops to the university and worried about the issues of location and funding. Bishops Keane and Ireland responded to those concerns as well as many others. Still the Pope kept them cooling their heels for nearly three months. Finally he made his decision. On April 10, 1887, Pope Leo sent a letter (below) to Cardinal Gibbons. It says, in part: "We therefore most gladly welcome and heartily approve your project for the erection of a University, moved as you are by a desire to promote the welfare of all and the interests of your illustrious Republic." The Catholic University of America celebrates Founders Day every year on April 10. The original of this letter was sealed inside the cornerstone of Caldwell Hall in 1888.

DILECTO FILIO NOSTRO

JACOBO

TIT. S. M. TRANSTIBERIM

S. R. E. CARDINALI GIBBONS

EX APOSTOLICA DISPENSATIONE

ARCHIEPISCOPO BALTIMORENSI

LEO PP. XIII.

DILECTE FILI NOSTER

SALUTEM ET APOSTOLICAM BENEDICTIONEM.

Quod in novissimo conventu anno MDCCCLXXXIV Baltimore habito communi Venerabilium Fratrum Americae Borealis Episcoporum voto propositum fuerat, de studiorum Universitate in istius Reipublicae gremio erigenda, id modo Tibi caeterisque Ecclesiarum istarum Pastoribus in animo esse reipsa auspicari, communibus literis die 25 Octobris elapso anno ad Nos datis intelleximus. Maxime vero delectati sumus praeclaro fidei vestrae testimonio, ac sincero pietatis obsequio in hanc Apostolicam Sedem, cujus patrocinio ac tutelae Academiam a primo eius exordio commendastis. Perpetua enim Pastorum ecclesiae praesertim vero Pontificum Maximorum laus semper extitit, veri nominis scientiam strenue provehere, studioseque curare ita disciplinas, imprimis theologicas ac philosophicas ad fidei normam in scholis tradi, ut coniunctis revelationis ac rationis viribus invictum inde fidei propugnaculum constitueretur. Itaque Decessores Nostri, de erudiendo Christiano populo vehementer solliciti, elapsis temporibus nullis unquam curis laboribusque pepercerunt ut in praecipuis Europae urbibus cele-

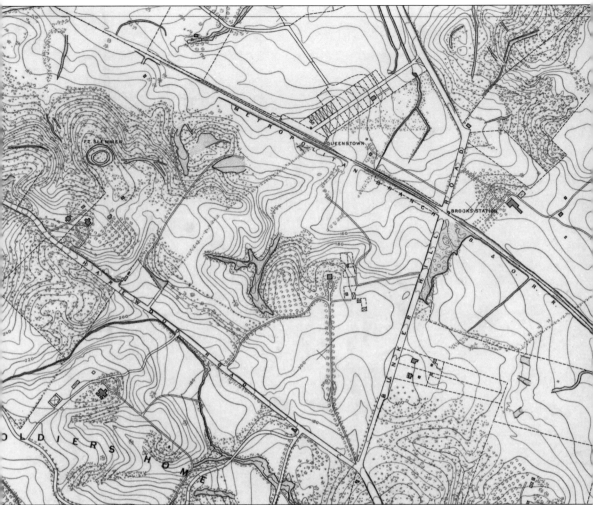

Now that the idea of the university was approved, the question of a location needed to be settled. A variety of places had been suggested, but only two were given serious consideration—South Orange, New Jersey, (with the idea of buying Seton Hall College) or an entirely new campus in Washington, D.C. The majority of the bishops voted for Washington, D.C., as did Mary Gwendolen Caldwell, who had been given ultimate authority to decide the site due to her largesse. The plot of land chosen, the Middleton estate, would place the university about 3 miles from downtown Washington, D.C., between the Soldiers' Home to the west and the Baltimore and Ohio Railroad tracks to the east. Visible on this 1887 map is the original manor house with its double row of cypress trees. On the northern edge of the property is Fort Slemmer, one of the circle of forts built during the Civil War to protect the city. (Map by Evans and Bartle; Courtesy of Library of Congress.)

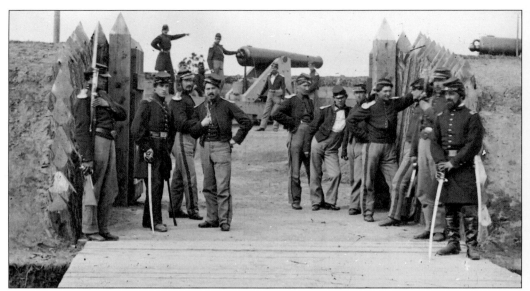

Fort Slemmer was one of the smaller forts and contained only four guns. Here soldiers—probably from the 2nd Pennsylvania Heavy Artillery—pose by the sally port. The fort saw no action during the war, with the troops spending their time drilling and keeping the fort in good repair. Only one of the 68 fortifications ringing the city was in a battle during the war—Fort Stevens, about 2 miles away. (Courtesy of Library of Congress.)

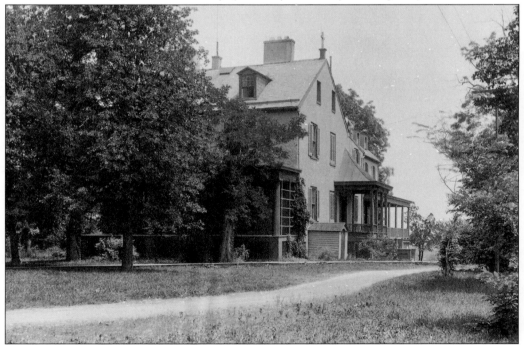

This 1896 photograph shows the manor house of the Middleton estate. It was called Sidney when it was built in 1803 by Samuel Harrison Smith, famed editor of the *National Intelligencer* and later president of the Bank of Washington. His wife, Margaret Bayard Smith, hosted some of the best-known names in early Washington, D.C., society at Sidney, including Thomas Jefferson and James and Dolley Madison.

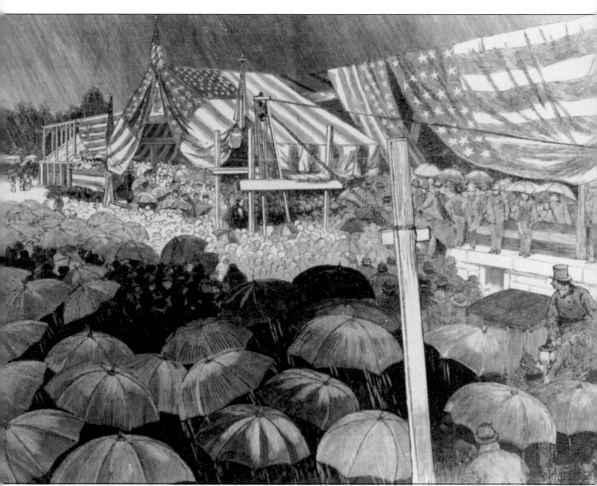

On May 24, 1888, in a pouring rain, the cornerstone was laid for the university's first building, then named Divinity Hall. On the dais were many luminaries, including Pres. Grover Cleveland, Cardinal James Gibbons, and Mary Gwendolen Caldwell, who was awarded a golden medal by Pope Leo XIII. Her mentor, Bishop John Lancaster Spalding, delivered an impassioned oration that went directly to the heart of what he wanted the school to be: "Certainly a true university will be the home both of ancient wisdom and of new learning; it will teach the best that is known and encourage research; it will stimulate thought, refine taste and awaken the love of excellence; it will be at once a scientific institute, a school of culture and a training ground for the business of life; it will educate the minds that give direction to the age; it will be a nursery of ideas, a center of influence."

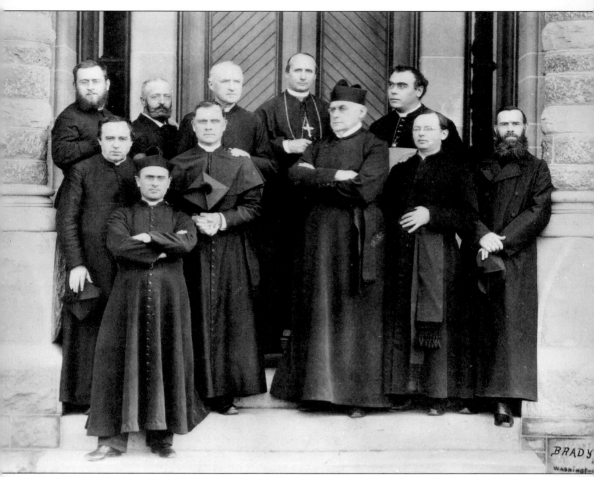

BRADY
Washington

Now it was time to find the teachers. Bishop John Keane had to achieve a balance between what was wanted and what was possible. As he wrote in his chronicles, "It was manifestly desirable that the teaching body should as soon as possible be chiefly composed of Americans, or at least English-speaking men. But for some time that would be manifestly impossible. Hence the first professors had to be sought abroad." In November 1888, Keane set off for a European recruiting tour. He returned with commitments from a group of fine scholars. Pope Leo XIII was pleased with the choices as well. From left to right, they are (first row) Rev. Thomas Bouquillon, Rev. Alexis Orban, Rev. Philip Garrigan, Rev. Augustine Hewit, Rev. Joseph Pohle, and Rev. Joseph Graf; (second row) Rev. Henri Hyvernat, Charles W. Stoddard, Rev. John Hogan, Bishop Keane, and Rev. Joseph Schroeder. All were priests except for Stoddard.

One of the brightest lights of the initial faculty was Rev. Henri Hyvernat, a scripture scholar, who was the first to be appointed in 1889 and who stayed the longest, heading the department of Semitic and Egyptian languages and literatures until his death in 1941. He gained international fame for his work in Coptic languages and brought an outstanding collection of books to Catholic University's Semitics library. (Courtesy of Library of Congress.)

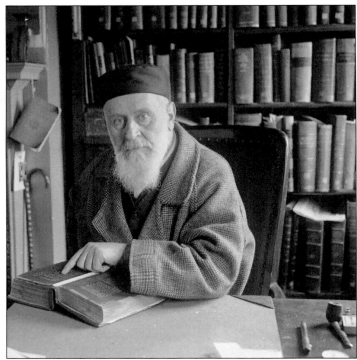

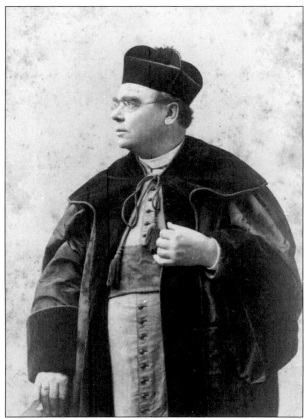

Rev. Joseph Schroeder was a German professor of dogmatic philosophy who thought he would enjoy teaching in America but soon became unhappy with CUA and its leaders. German Catholics were agitating in Rome for more autonomy within the American church, and that developed into a bitter fight against "Americanists" such as Rector Keane. Schroeder was blamed for faculty disharmony, his teaching was criticized, and he was forced to resign.

23

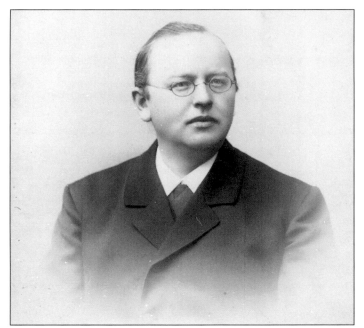

Bishop Keane was initially elated when he arranged for Rev. Joseph Pohle to teach Thomistic philosophy at Catholic University, calling him "one of the first philosophers of Germany." That changed when Pohle got caught up in the German/Americanist brouhaha. Like fellow faculty member Joseph Schroeder, Pohle became disenchanted with CUA and resigned with some acrimony in 1894.

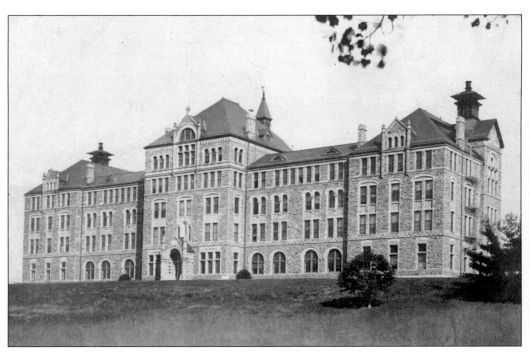

By late 1889, Divinity Hall was completed. The Catholic University of America formally opened its doors on November 13 of that year, and just as at the cornerstone laying a year earlier, the skies opened and rain poured down on the visiting dignitaries, which included Pres. Benjamin Harrison, Vice Pres. Levi Morton, the secretaries of state, interior, and agriculture, and the U.S. Marine Band under the direction of John Philip Sousa.

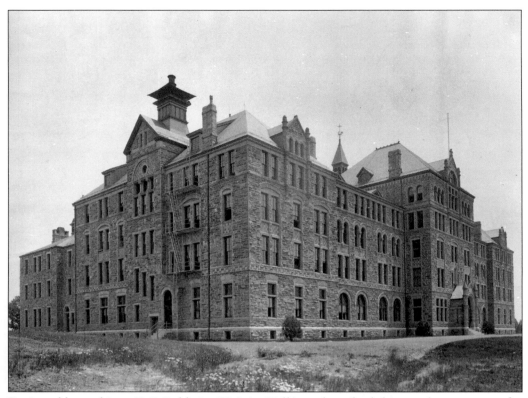

Designed by architect E. F. Baldwin, Divinity Hall was described this way by a reporter for the *Washington Post*: "The architecture is massive, simple, and severe. It is the only example in the city of modernized Romanesque architecture. There are no insulated columns, no pointed arches or intricate ornamentation. It depends for its effects upon the eye on its severe simplicity of outline and harmonious proportions."

The building does have some human touches, however. The finials above the center and wings of the building are topped with six ideal figures representing philosophers, and a variety of grotesques adorn the window archways and the main entrance. They were likely created by Bryan Hanrahan, a stone mason who worked for the architectural firm of Baldwin and Pennington. (Courtesy of the author.)

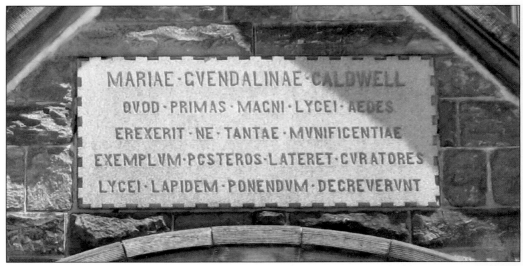

MARIAE · GVENDALINAE · CALDWELL
QVOD · PRIMAS · MAGNI · LYCEI · AEDES
EREXERIT · NE · TANTAE · MVNIFICENTIAE
EXEMPLVM · PGSTEROS · LATERET · CVRATORES
LYCEI · LAPIDEM · PONENDVM · DECREVERVNT

This plaque was installed over the main entrance of Divinity Hall. Written in Latin, it translates: "Mary Guendaline Caldwell. Because she has erected the first abode of a great school, the directors of the school ordered this stone tablet to be put up, so that posterity might not forget an example of such great munificence." (Courtesy of the author.)

Mary Gwendolen Caldwell's younger sister Mary Elizabeth, known as Lina, contributed $50,000 for the exquisite Beaux-Arts style chapel in the building. It was here that the high mass was celebrated on opening day in 1889; it was so crowded that Cardinal Gibbons had difficulty leading the procession into the chapel. A year later, Lina Caldwell was married here.

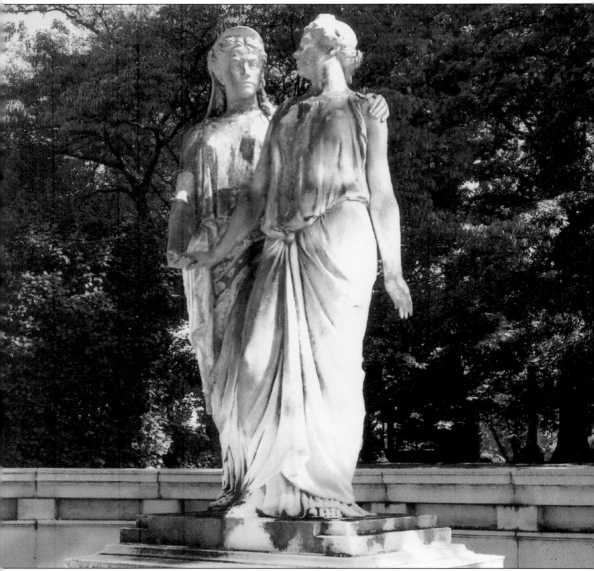

This is the memorial to the Caldwell sisters at Cave Hill Cemetery in Louisville, Kentucky. Both Mamie and Lina married faded European royalty. Mary Gwendolen's union with the Marquis Jean des Monstiers Merinville was not a happy one and produced no children. She had earlier been engaged to a grandson of the king of Naples, but when he insisted she turn over to him half of her inheritance, she broke it off. Lina married Baron Kurt von Zedtwitz, a German diplomat and a Lutheran. Both sisters eventually renounced the Catholic Church, with Lina even publishing an anti-Catholic screed in 1906. Mamie also turned against her old friend Bishop Spalding, at one point referring to him as a "whited sepulcher" and a corrupt person who professed to be virtuous. She was quite ill with kidney disease during this period and died not too long afterwards at the age of 45. Lina died in 1910; she was 44. (Courtesy of Rev. Clyde Crews.)

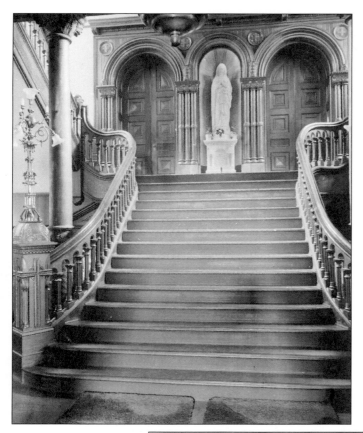

Anyone who visited the building in its early days was impressed by the main stairway rising five stories in a split-and-return pattern, made of carved oak with ornamental iron columns. The statue of the Virgin stands a half story above the main vestibule, between the twin doors of the chapel entrance. Within a decade the building was being referred to as Caldwell Hall, rather than the Divinity Building.

Rector Keane thought a library "one of the first cares of every institution of learning" and gave priority to its establishment. The board authorized enough money for the library to acquire an initial 8,000 volumes. Rev. Alexis Orban was appointed the first librarian and began to set up shop in the basement of Caldwell Hall.

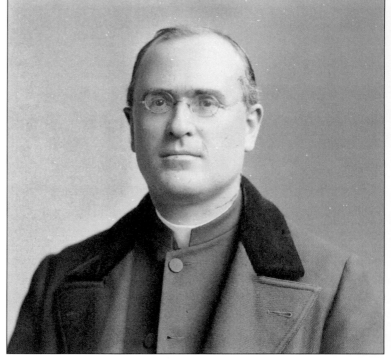

Early on, the university had extended invitations to all religious congregations to establish houses of study around the university. The Paulists were the first to accept and were temporarily given the Middleton manor, pictured in the 1920s after many modifications. They called it St. Thomas Aquinas College, and when it reverted to the school in 1913, it became St. Thomas Hall.

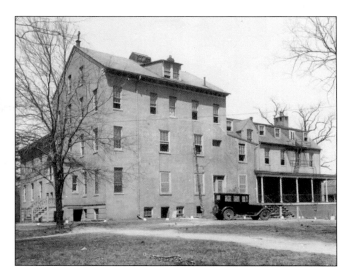

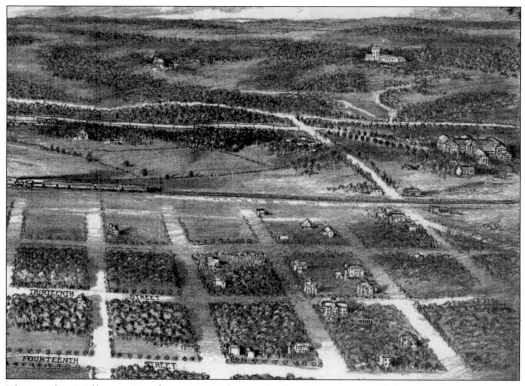

This realtor's illustration from 1889 shows the bucolic nature of the university area. In the center at far right is a surprisingly accurate drawing of Caldwell Hall. Above that is the main building of the Soldiers' Home, and in the upper left center is Howard Hall at Howard University. The railroad cuts across the center of the picture, with the sparsely populated community of Brookland just below. (Courtesy of Library of Congress.)

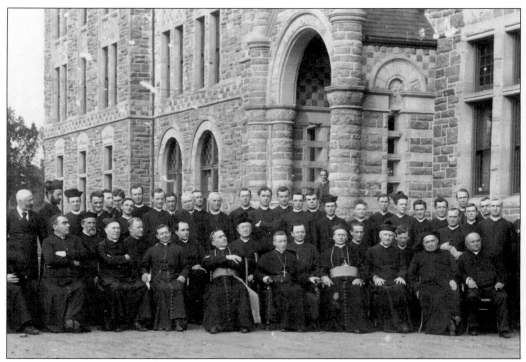

This picture was taken in 1893, on the occasion of a reception honoring Cardinal Gibbons (seated, center) on the 25th anniversary of his episcopal consecration. This small group is not the entire faculty and student body that year, but there were not all that many more. The school was growing more slowly than anticipated. By the 1895–1896 academic year, there were seven professors and only 115 students.

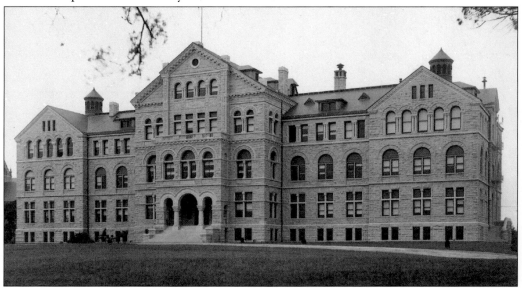

Despite low enrollment, the university did expand, as Rector Keane had promised it would. He had said at the beginning that he would establish a school of philosophy and letters. When Rev. James McMahon bequeathed real estate worth $400,000 to the university, it was used to erect a building to house that school, McMahon Hall, in 1895.

Here are two pages from the inaugural program of McMahon Hall in 1895. Rev. Francesco Satolli, the country's first apostolic delegate, was a respected scholar and a powerful man in the Vatican. Deeply involved with the university's early life, his views were sometimes contentious. On this occasion, he spoke for an hour in Latin. Cardinal Gibbons, speaking in English, said, "In the swift race of intellect, in the widespread passion for knowledge, noble and praiseworthy as it is, Catholics must lead, not follow, must be adepts in all the refinements of learning, and apply themselves strenuously to the search after truth, and the investigation, so far as may be, of nature's entire domain."

Deus Lux Mea

Dedication of the

McMahon Hall of Philosophy

of the

Catholic University of America

And Inauguration of the

Faculties of Philosophy and of the Social Sciences

Tuesday, October 1, 1895

At 3 p. m.

Programme

I. Blessing and Dedication

Of the McMahon Hall of Philosophy, by His Eminence Cardinal Gibbons, according to the formula of the Roman Ritual, at 3 P. M., the Directors of the University and other Prelates assisting.

II. Inaugural Exercises

BRIEF OF THE HOLY FATHER: Read by the Rt. Rev. Rector.

PHILOSOPHIA ET FACULTAS PHILOSOPHICA: By the Most Rev. F. Satolli, Delegate Apostolic.

THE SCHOOL OF PHILOSOPHY: By Rev. Prof. E. A. Pace, Ph. D., D.D., Dean of the Faculty of Philosophy.

THE SCHOOL OF THE SOCIAL SCIENCES: By Prof. W. C. Robinson, LL.D., Dean of the Faculty of the Social Sciences.

CHANCELLOR'S ADDRESS: By His Eminence Cardinal Gibbons, Chancellor of the University.

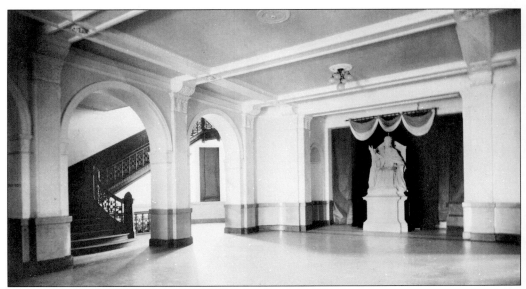

This is the lobby of McMahon Hall as it appeared when it was first built. The 12-foot-high statue of Pope Leo XIII was created by Italian sculptor Giuseppe Luchetti and was packed in seven crates and shipped from Naples, Italy. It remains in this same location to this day.

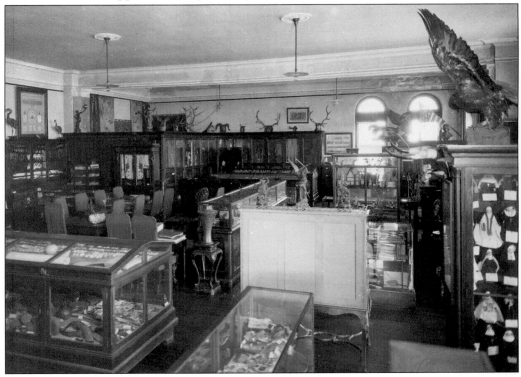

Rector Keane and other early administrators thought a university museum was an essential tool in teaching and so accepted a donation of fossils and minerals even before the first building was opened. Stored in Caldwell Hall at first, the museum moved to McMahon Hall soon after it was built. The collection is today administered by CUA's archives and is divided into three categories: art and artifacts, history, and anthropology.

Standing outside McMahon Hall, which housed the school of philosophy, is Rev. Edward A. Pace, in 1904 the newly appointed dean of the school. Rector Keane had wanted Pace for the original faculty, but he had to wait while Pace finished his studies with Wilhelm Wundt, the world's first experimental psychologist. Pace was a gifted scholar, with a mind that a future rector referred to as "a calm serene region." The experimental psychology laboratory he set up in McMahon Hall in 1899 was one of the earliest in the world. Pace served the university for 41 years as general secretary, vice rector, and lead editor of the *Catholic Encyclopedia*, with three stints as dean of the school of philosophy.

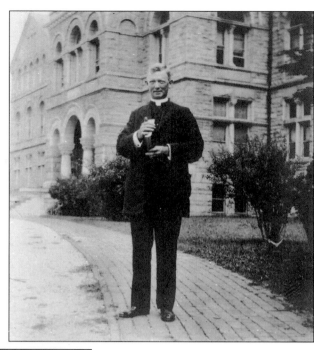

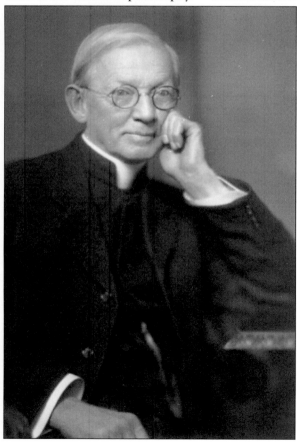

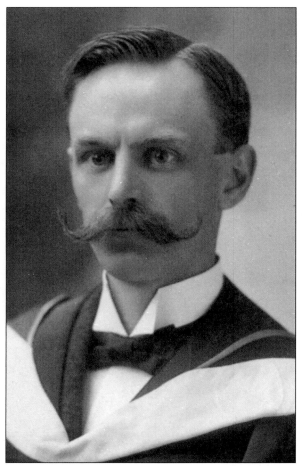

Another history-making laboratory was set up during the school's first decade. One of the pioneers of early flight, Dr. Albert Zahm, taught mechanics at CUA starting in 1895. He constructed a 30-by-80-foot frame building to house one of the country's first wind tunnels (below). Endowed by a wealthy businessman, Zahm made a number of important discoveries there, including proof that the friction of air over an aircraft's skin was a major cause of drag at subsonic speeds. Unfortunately, after his sponsor's death in 1902, funding became difficult, and Zahm left the school in 1908. Though friendly with the Wright brothers early in his career, Zahm developed into their adversary after he left CUA and became chief engineer for the Wrights' rival, Glenn Curtiss.

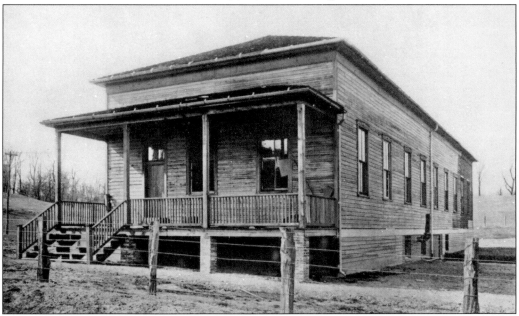

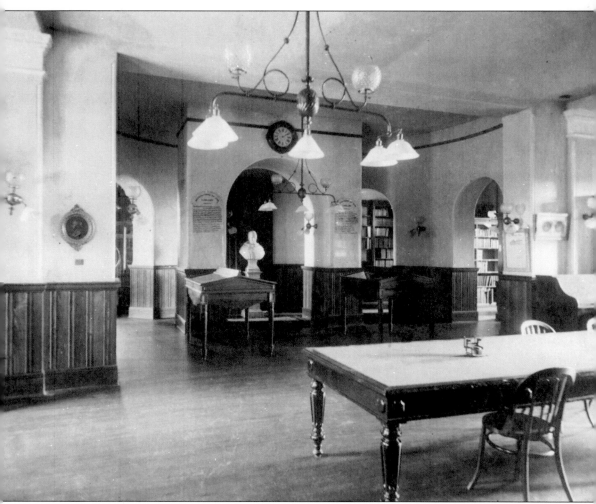

In 1888, a year before the school opened, the board named Archbishop Corrigan chairman of a committee on the university library, and it authorized him to spend $5,000 to form its collection. The first library was set up beneath the chapel in Caldwell Hall. After a year, this space was deemed too small, and with some renovation, the library spread out over the entire basement of Caldwell (above). It was not an easy task to build a library with little money. The board had authorized no expenditures beyond the initial funds, so the library relied on donations of books from friends of the university. That brought in some reasonable acquisitions but not enough to properly stock a university library. It was not until 1893, after continual pleading from the librarian, that some money began to be budgeted regularly. In 1895, Joseph Banigan, one of the school's trustees, offered a generous donation that finally put the library on a secure footing.

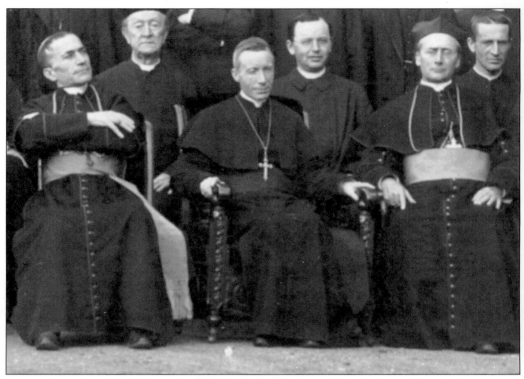

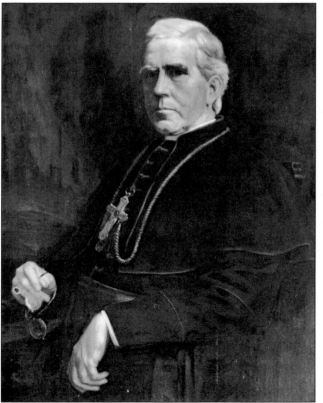

Money problems plagued Rector John J. Keane throughout his tenure. From the beginning, he had pushed for a national diocesan collection to support the university but was not able to get approval. Money was not his only difficulty. The new apostolic delegate, Archbishop Francesco Satolli (soon to be a cardinal), had never thought much of Keane's philosophical and educational training but mostly objected to his liberal Americanism. Pope Leo XIII dismissed Keane as rector in 1896. In the above picture from 1893, seated in the first row from left to right are Archbishop Satolli, Cardinal James Gibbons, and Bishop Keane. Keane took his removal with equanimity, but others were more upset. Repercussions from the incident lasted for some time. Keane was replaced by Bishop Thomas J. Conaty (to the left).

Two

Early Days,
Early Challenges

With the departure of Rector John Keane, Catholic University tried to get its bearings as the 19th century came to a close. The going was not easy, with finances as the primary issue. From the beginning, Keane had pressed for an annual diocesan collection to support the school, but there were many roadblocks. The school's board of trustees preferred the original plan of support by endowment—soliciting funds from wealthy Catholics—so they sent the rector out on fund-raising trips. Getting the nation's bishops to agree to contribute to the university was not an easy task when many of their own parishes were needy. One Louisiana cleric did not think his parishioners could "take advantage of higher education" and so wondered why they should "contribute to the education of the sons of the rich." A pastor from Wisconsin did not believe a contribution from his parish was essential, since surely the university would be supported "if from no other motives, at least from mere human pride in such a magnificent Institution."

Mere human pride was not enough to bring in the needed funds or the students. Enrollment at the university was not what had been expected. Persuading bishops to send a young priest to Washington for a few years was a hard sell, even though tuition costs were often minimal. As Rector Keane wrote, "It is recognized that fees must be charged, lest even the foolish should seem justified in supposing that learning is of no value; but it is also recognized that practically the requirement of fees should be so minimized by free scholarships and other such methods, that the poor man's son can have just as good a chance in the noble strife for intellectual superiority and for all the success and preeminence in life which this implies, as the son of the rich man has."

With those difficulties to surmount, the university took a deep breath and headed into the 20th century.

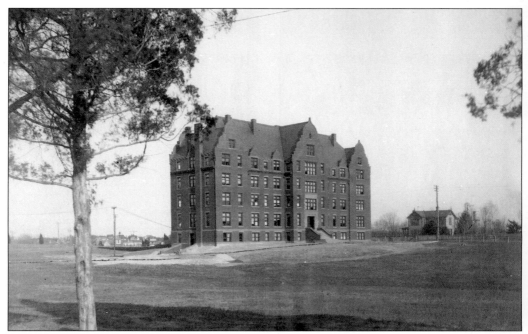

CUA was originally conceived as a graduate school for religious students, but it soon became apparent that in order to survive, the university would need to admit lay students as well. This lonely looking building is Albert Hall, originally called Keane Hall, the first dormitory for lay students. Still new when this picture was taken in 1896, it was the first of the campus buildings erected along Michigan Avenue.

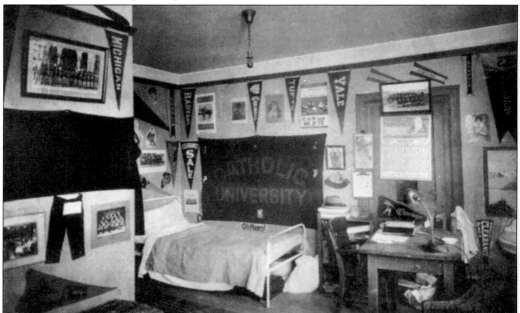

The rooms inside Albert Hall were not sumptuous but sufficient. This picture from the 1920s shows the standard accoutrements of a college dorm room: pennants from a variety of colleges, pictures of sports teams and pretty actresses on the walls, and a sturdy little desk for hard studying. Albert Hall was demolished in 1970.

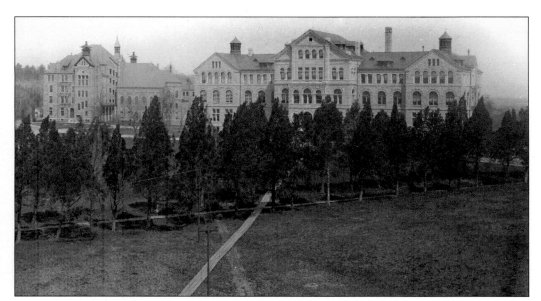

This is a view of Caldwell and McMahon Halls at the time Thomas Conaty took over as the second rector of the university. The double row of cypress trees lined the original path to the Middleton manor, which was now serving as St. Thomas Aquinas College of the Paulist Fathers. Pres. Theodore Roosevelt was impressed by the trees when he made an impromptu visit a few years later.

In 1902, the Catholic Missionary Union, of which the Paulists were a part, wanted to set up a new program to train diocesan priests for mission work, and they asked to affiliate with CUA. Soon a new building, the Apostolic Mission House, was erected on Michigan Avenue in a style variously described as Italianate or old Mission.

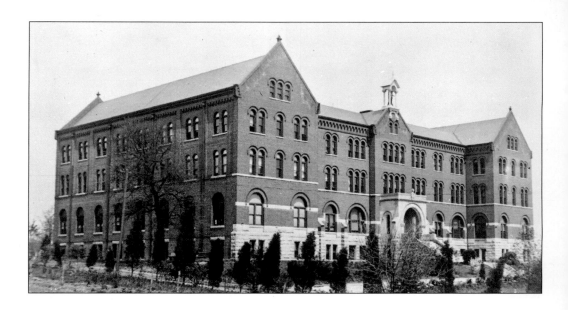

Soon more Catholic institutions associated with the university. In 1900, the Society of Mary opened Marist College (above) near the old Fort Slemmer, and the Congregation of the Holy Cross built Holy Cross College next door (below). Marist was designed in the Victorian/ Romanesque style and made of red brick with a rusticated Indiana limestone foundation. Holy Cross was Beaux-Arts/neoclassical and made of grey limestone. The Catholic University of America purchased both buildings in the mid-20th century. Holy Cross College was renamed O'Boyle Hall in honor of Cardinal Patrick O'Boyle, the third chancellor of the university. Marist College was simply changed to Marist Hall. (Above, courtesy of Library of Congress.)

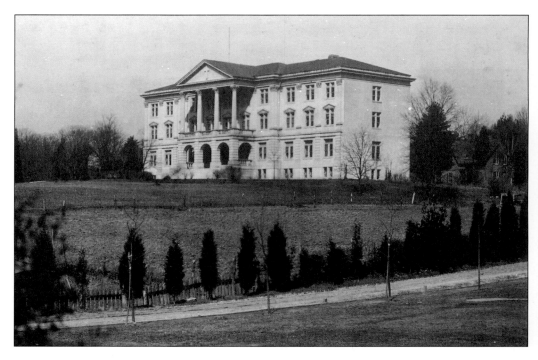

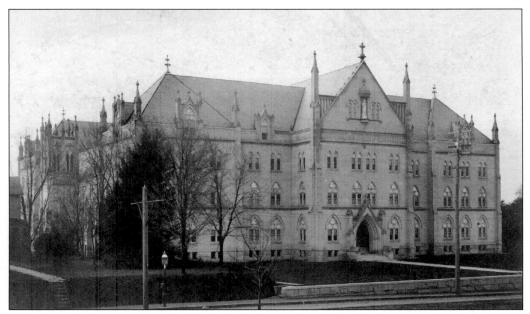

Not every institution that considered affiliating with the university was happy with the terms set forth, which would give CUA overall supervisory authority. At first the Dominicans did not want to sign, but after a few years of negotiations, the two parties finally agreed on an affiliation plan. In 1903, the Dominican House of Studies was opened across Michigan Avenue from the main campus.

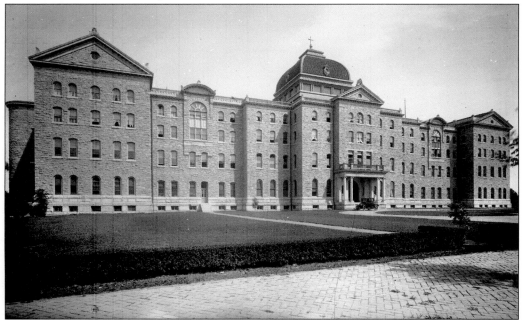

Catholic University was an all-male school, but women began to petition for admission. Neither Cardinal Gibbons nor the Vatican was inclined to allow it. In 1897, vice rector Rev. Philip Garrigan visited the sisters of Notre Dame de Namur and asked them if they would start a women's college. In 1901, Trinity College was dedicated just down the street from Catholic University. (Courtesy of Library of Congress.)

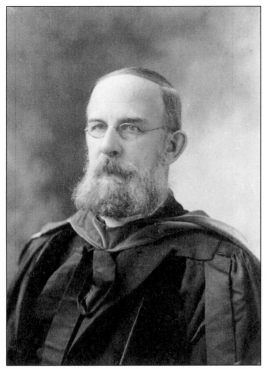

Beyond the original faculty, the board of trustees also contracted with some lecturers, including Rev. George M. Searle. His province was physics and astronomy, and he soon set about building an observatory (below), which was completed in 1890, a year after the school opened. Set on what was then the highest point on campus, the observatory contained a 9-inch equatorially mounted telescope, as well as a meridian circle, sidereal clock, chronograph, and chronometer. In 1892, observations of a number of comets were recorded and published, including data that led to an understanding of the periodicity of Holmes's Comet. The observatory burned to the ground in 1924 and was never rebuilt. The base for the telescope still exists on the pathway between Curley Court and Centennial Village.

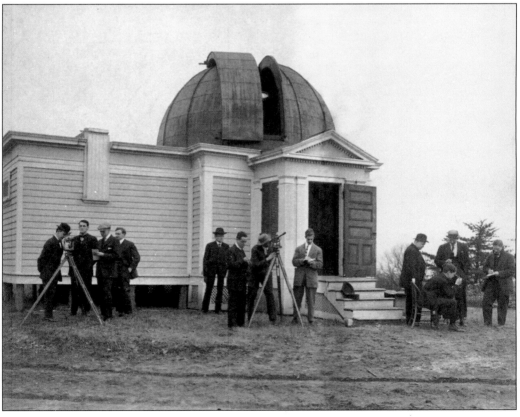

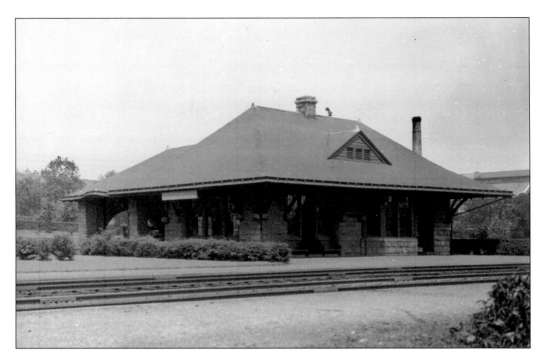

Constructed in 1890, University Station was erected on a small parcel of campus land donated by the university. Built of granite, this sturdy little structure served both the school and the Brookland neighborhood. Until streetcar lines were extended, the metropolitan branch of the Baltimore and Ohio Railroad provided the only means of mass transit to downtown, as can be seen from the ticket below. The train also connected to the American west through Harper's Ferry. University Station burned in 1940, though its husk functioned into the 1960s as a whistle stop. It was completely demolished for the building of Washington's subway in the 1970s. An entrance to the Brookland Metro stop now occupies the space where this building stood.

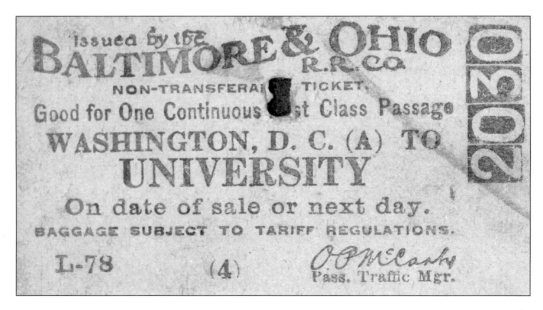

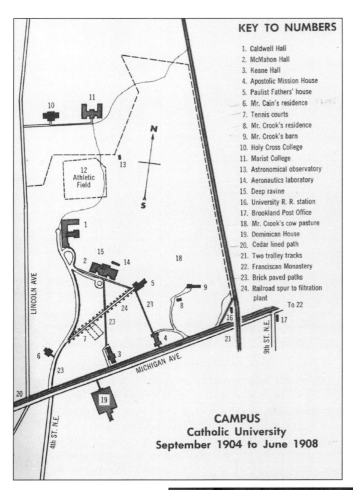

CAMPUS
Catholic University
September 1904 to June 1908

This map of the university in 1904 shows, on the eastern side of campus, two buildings labeled as Mr. Crook's house and barn, right next to a cow pasture. Nicholas Crook was the groundskeeper and general manager for the university during the era when much of the food for students and faculty was produced on campus. His son, Louis, was awarded a scholarship and received his bachelor's degree in 1909. After graduate study at Johns Hopkins University, he worked for Albert Zahm, the former Catholic University professor who did pioneering work with wind tunnels and aeronautics. Louis Crook then came back to teach at CUA, eventually becoming dean of the department of aeronautical engineering, until his death in 1952. (Map courtesy of Catholic University of America Press.)

The third rector was Msgr. Denis J. O'Connell, and there were significant changes during his tenure. For financial and academic reasons, it was decided to admit undergraduates. Then came an unexpected and serious financial crisis. At No.16 on this list of university trustees from the 1887 Acts of Incorporation (below) appears the name Thomas E. Waggaman, who served as the first treasurer. He had been entrusted with the university's endowment fund. Waggaman gave promissory notes to the school and used the money to purchase real estate in the Woodley Park area of Washington. The security he offered was grossly insufficient, and there were discrepancies in his records. The university took him to court and six years later settled for only 40 percent of Waggaman's debt. The school had lost hundreds of thousands of dollars and was now in very difficult straits.

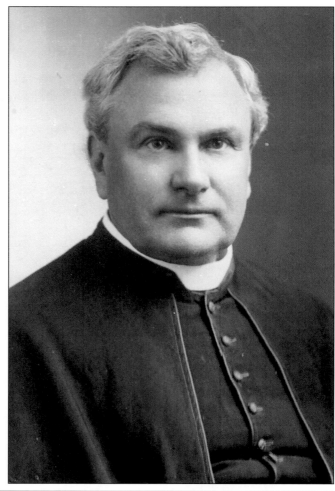

16. Thomas E. Waggaman, of Washington City, D.C.
17. Michael Jenkins, of Baltimore City, Maryland, have associated and do hereby associate ourselves for the purpose of establishing an institution of learning in the District of Columbia, of the rank of a University, and in order to become a body corporate under the General Incorporation Act of Congress enacted for said District of Columbia, we execute these presents, and we do hereby certify as follows: First,

45

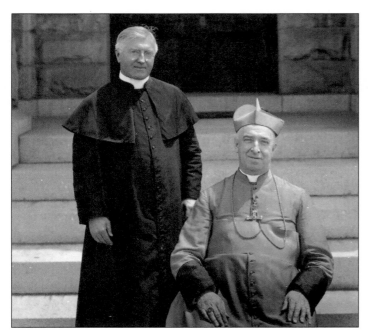

The admission of undergraduates and the long-awaited papal approval of a yearly diocesan collection for the university helped overcome the financial debacle and reinvigorate the school. Still, Rector O'Connell had a rocky relationship with the faculty and desired to leave his post. The board complied, and in 1909, the Very Reverend Thomas Shahan was named the fourth rector. He is pictured here (seated) with his secretary, Rev. Bernard McKenna.

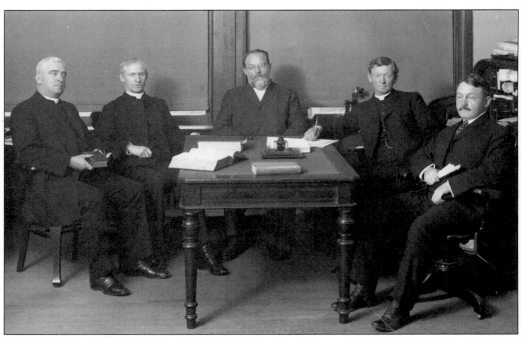

In addition to becoming rector, the Very Reverend Thomas Shahan was also one of the editors of the *Catholic Encyclopedia*, a monumental undertaking begun in 1903 and finished in 1912. Seated from left to right in this photograph of the editors are Shahan, Rev. John J. Wynne, Charles G. Herbermann, Rev. Edward A. Pace, and Conde B. Pallen.

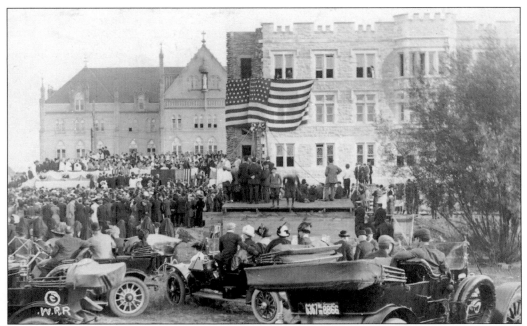

With the admission of undergraduates, enrollment picked up substantially. New buildings were needed, and Rector Shahan showed a distinct affinity for campus development. Albert Hall became the undergraduate dormitory, and a new dorm named after Cardinal Gibbons was built next to it. The cornerstone laying occurred on October 12, 1911, and was a major event with a huge crowd, many dignitaries, and a long procession from McMahon that even included a section of the U.S. Marine Band (see cover photograph). The photographer then climbed to the top of Albert Hall to take another photograph from a different angle (below). The stand that holds the dignitaries is placed where the towers of the building will be erected.

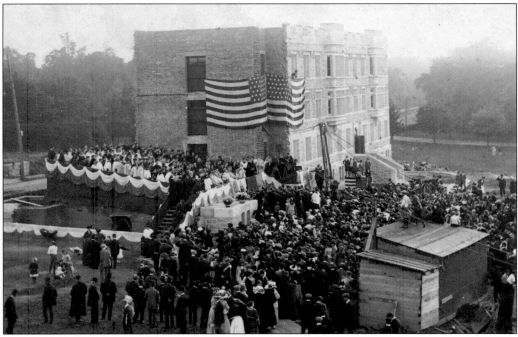

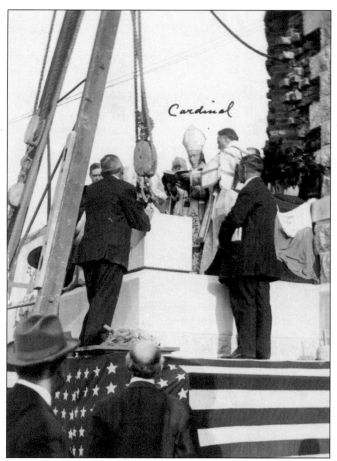

Cardinal

In the photograph to the left, Cardinal Gibbons is blessing the cornerstone. Although he was not scheduled to speak, the gathered crowd urged him to say something, and he complied with a few brief remarks. It was a beautiful fall day, and the cardinal could not help commenting on the weather. "I cannot fail to contrast the dark day when we laid the first cornerstone of the Catholic University with this bright, sunshiny day," he said. "It brings to mind the scriptural words that 'They who sow in tears shall reap in joy.'" Below is another photograph of the construction taken a little later from the Michigan Avenue side of the building, after the central tower complex was completed. The flags and banner in the center are to honor the Knights of Columbus.

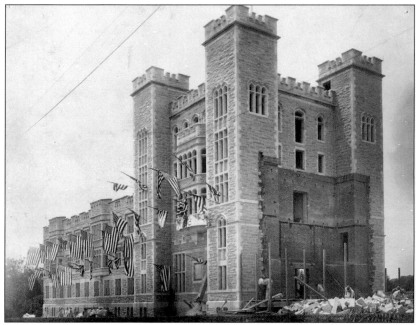

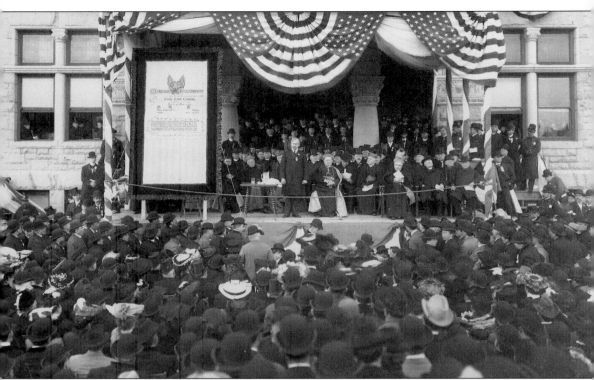

The Knights of Columbus, one of the country's leading Catholic fraternal organizations, has always been a great friend to the university. This image from 1904 shows the presentation of a $50,000 gift from the Knights to CUA. The oversize check, seen on the left of the photograph, hung in the main dining hall of the school for many decades. Rev. Michael McGivney had founded the Knights of Columbus in 1882, when he was a 29-year-old assistant pastor at St. Mary's Church in New Haven, Connecticut. The fraternal benefit society grew rapidly and now claims more than 1.7 million members. They have contributed billions of dollars to various charities, and they also have been ardent supporters of America's war efforts, beginning with the Spanish-American War of 1898. A building on CUA's campus was named in Father McGivney's honor in 2008.

The $50,000 check was not the only substantial gift from the Knights. They donated a chair of American history, and in 1914, they transferred to the university $500,000, which had taken them six years to raise. The money was to endow fellowships for graduate study and proved an invaluable contribution to the university over the years. In 1999, CUA president the Very Reverend David O'Connell said, "This generosity, which continues to the present day, has enabled countless numbers of students—children of the Knights among them—to experience the benefits of a Catholic university education." In addition to major donations, the Knights of Columbus also contributed to campus life in smaller ways, sponsoring dances (above), war fund drives (below), and other fund-raising activities.

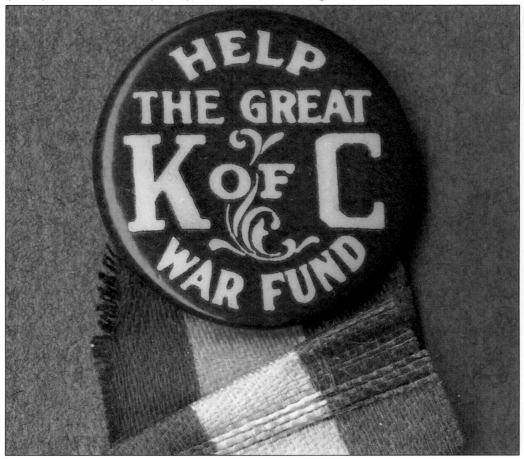

Built at about the same time as Gibbons Hall in 1910–1911, the power plant, with its yellow clay tile smokestack, became a campus and neighborhood landmark. It was erected near the university groundskeeper's house in what was once a cow pasture. According to the school's Web site, the power plant originally supplied both power and heat for the campus, "an early example of coal-fired steam electrical generation combined with a heating facility." As can be seen in this image from 1912, the building had an ornate industrial style that is unique on the campus. It was designed by the firm of T. H. Poole. Below is a picture of the interior with some new boilers that were installed in the 1930s.

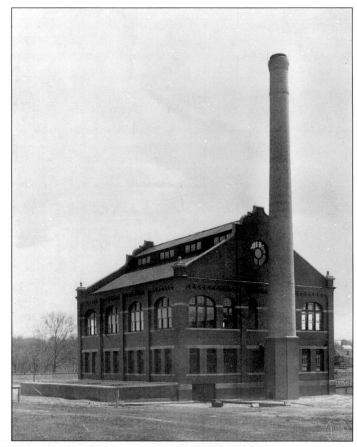

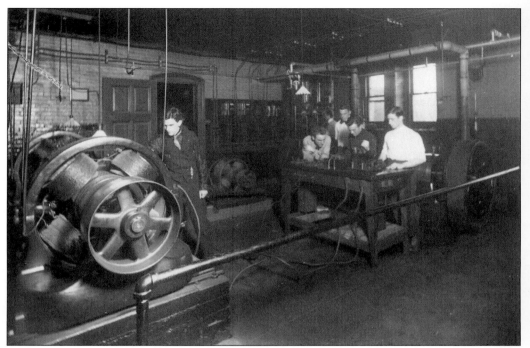

The power plant was built on the east side of campus along Boulevard Avenue, which the university requested be renamed Brookland Avenue. In 1985, the university asked the city to change the name again, this time to John McCormack Road, in honor of the Irish tenor's centenary. Early in its life, the building also housed some classes, such as this one in mechanical engineering from 1913.

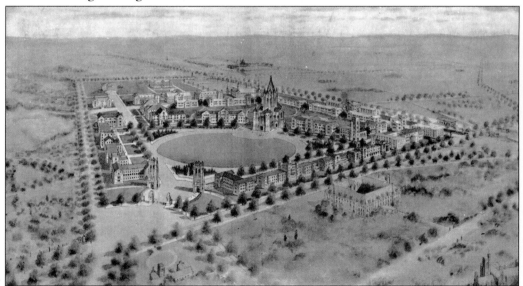

Rector Thomas Shahan's affinity for the collegiate Gothic style of architecture is evident in this plan for the university, made under his direction. All the campus buildings depicted are fanciful except for Caldwell, McMahon, and Gibbons Halls. Note particularly the Gothic university church, not at all like the National Shrine of the Immaculate Conception, which Shahan would shepherd into being.

Under Rector Shahan, Catholic University began to exert influence in the broader arena of Catholic education. He said the university had become "a fertile source of general Catholic services, educational and charitable," particularly in the field of teacher training. Rev. Thomas Edward Shields was instrumental in that area. He came to the university in 1902 and established himself in the department of education, soon becoming the dean. He was especially interested in the preparation of teachers for Catholic schools, so they could better compete with public schools. In 1912, he took control of the summer session for women. It had started a year earlier as part of the university and was a big success. Shields purchased farmland a half-mile northeast of campus and established the Catholic Sisters College, which was incorporated separately from the university. For six weeks in the summer, the students of the teachers college, primarily religious women, came to classes on CUA's campus. This 1923 photograph of the Sisters College campus was taken from the future site of a building that would be named for Shields.

Designed as a companion building to Gibbons Hall, Graduate Hall was also built in the collegiate Gothic style. It opened in 1914 and housed fellows from the Knights of Columbus and other graduate students. The building's real mark of distinction was not the student rooms, however; it was the massive dining hall that could accommodate 600 people. The decor was Tudor Gothic, as is evident in the 1916 photograph below, and the room hosted a variety of special events in addition to the daily meals. The building was originally intended to have a chapel, but more dining and residential space was added instead. Wings were built on the east side in 1959 and the west side in 1962.

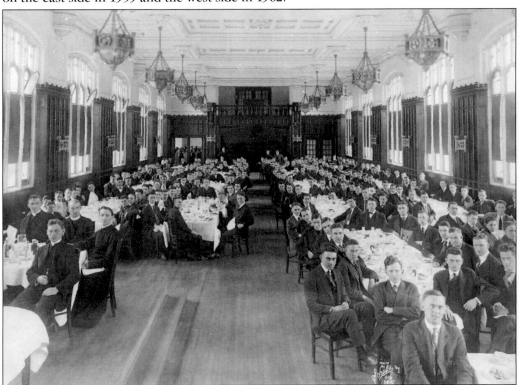

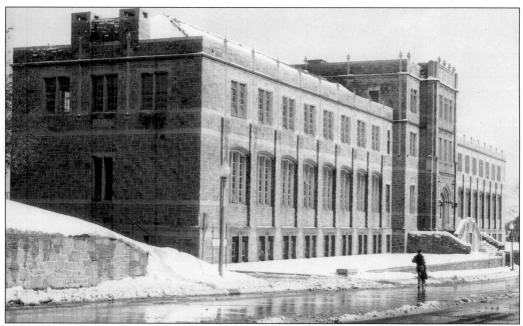

Constructed at the same time as Graduate Hall, the Martin Maloney Chemical Laboratory was designed and built as a cutting-edge facility. The labs (below) had a state-of-the-art vapor and gas evacuation system. Major experimental research was conducted here right from the start. When Pres. Woodrow Wilson declared war against Germany in 1917, Cardinal Gibbons offered him the university's facilities to support the effort. Under government supervision, the deadly gas Lewisite was developed in Maloney Hall. A blistering agent and lung irritant, the gas was not used in World War I, though experiments continued until it was declared obsolete in the 1950s.

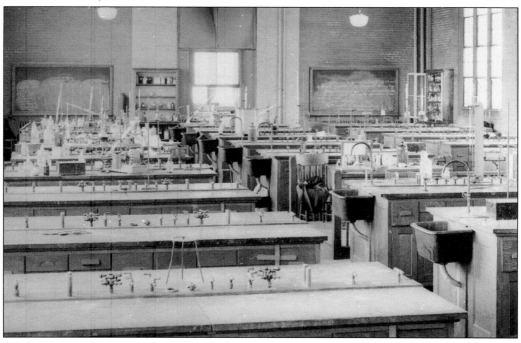

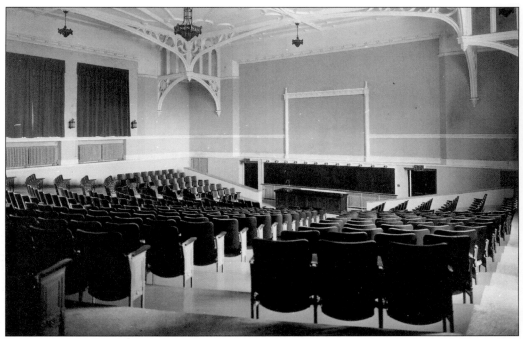

Maloney Hall turned out to be the last structure on campus built in the collegiate Gothic style. The showpiece of the building was its auditorium (above), which was added a few years after the main hall when Martin Maloney contributed $100,000 for its construction. Completed in 1926, the auditorium, which seats 500, had modern slide and movie projection capabilities. The room hosted a variety of special lectures over the years in addition to regular chemistry instruction. Before Maloney Auditorium was available, lectures were held in a number of classrooms, including the packed one below, from a picture taken in 1913.

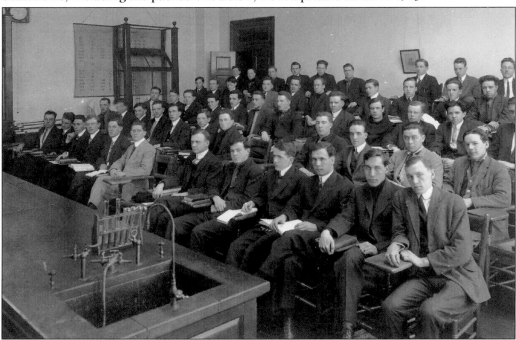

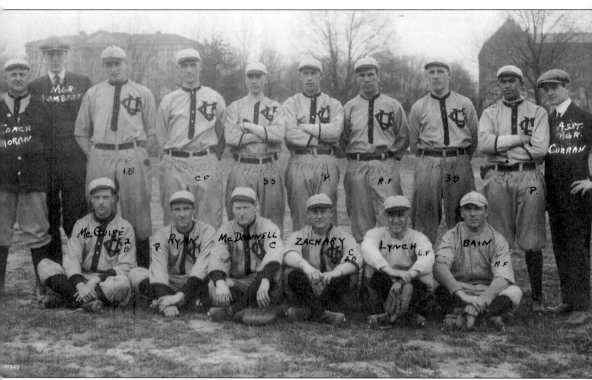

With the admission of lay students and undergraduates, sports began to take on more prominence at the university. Perhaps the most famous sportsman to graduate from Catholic University, Wally Pipp (second row, left), played first base for the New York Yankees from 1914 to 1926 before being traded to the Cincinnati Reds. How he lost his job with the Yankees became the stuff of baseball legend. As the story goes, Pipp had a headache on June 2, 1925, and told the manager to sit him out. He was replaced with a young kid from Columbia University named Lou Gehrig, who went on to hold the position for the next 14 years, playing 2,130 consecutive games. The story about the headache is probably not true. It seems most likely Pipp was replaced because he was in a slump, but he did indeed lose his job to the future hall of famer. O'Boyle and Marist Halls can be seen behind the team in this 1913 photograph.

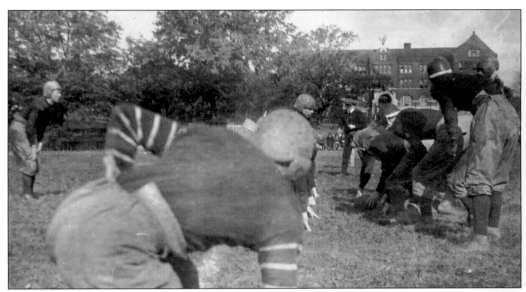

The above snapshot from a student photograph book of 1923 shows an intramural football game being played on the CUA "playing field," basically a flat piece of ground between Caldwell and Marist Halls. It was the only concession that then Rector O'Connell had been willing to make to students pressing for athletic facilities. The field was covered with brush and not perfectly level, so a few students travelled to Baltimore to see if Cardinal Gibbons might be willing to help. He was, hiring a Brookland contractor with two teams of horses and several men who turned it into a suitable playing field in 1905. Curley Hall now stands on the site. Below is a portion of an aerial photograph from 1923 showing the playing field on the far left and the edge of Caldwell Hall on the right.

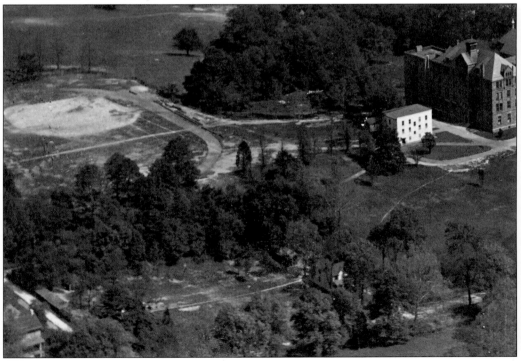

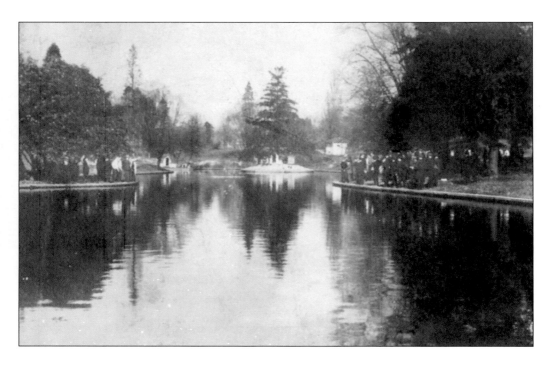

Some of the sports were not exactly varsity level. One of the early traditions of the university was an annual tug-of-war between the freshman and sophomore classes. The challenge did not take place on campus, however. The students would trudge across the grounds of the Soldiers' Home next door and set up on either side of a small lake there (above). In this tug-of-war from 1917, the freshmen lost and wound up getting wet (below). The lake still exists, but the Soldiers' Home (officially called the Armed Forces Retirement Home) is now closed to the public.

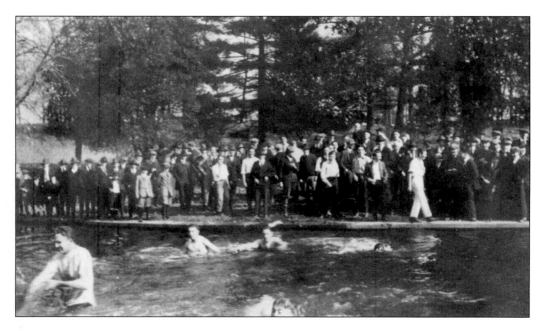

Baseball was enormously popular during the early years, as is apparent in this 1917 cartoon printed in a student magazine called *Campus*. This is from the scrapbook of one of the players depicted, Jim Carroll. His memorabilia collection is crammed with photographs, ephemera, and newspaper clippings about the baseball team's exploits.

MID-YEAR, 1916-1917.

RELIGION II A (Freshmen)

✓ I. What is the Catholic answer to the question: from what did Jesus Christ save us and how did He do it?

II. State, differentiate and explain the three main Catholic theories of redemption.

III. Show how St. Thomas' theory of Moral Reparation, far from doing violence to the modern conscience, reconciles the claims of love and justice and makes for the individual and social uplift.

IV. State and explain the views of the Protestant Reformers apropos of redemption and trace the metamorphosis through which Protestant thought has passed in this regard.

V. Give an outline of the Savior's character, claims and method of Self-revelation, indicating the part played by his miracles and teaching method in the general scheme.

VI. State and answer any two questions proposed in the Question Box.

N. B. Candidates are free to elect any four questions.

Of course, school life was not all play, and studies always took precedence. At left is a 1916 mid-year examination in freshman religion that would still be considered difficult for first-year students today. Religious instruction, which included history, comparative analysis, and interpretation, was naturally a major part of every student's curriculum, both lay and religious students.

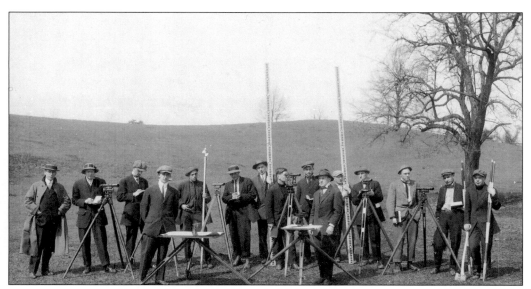

There was also instruction in nonreligious course work, both in and outside the classroom. In this photograph from 1913, civil engineering students use Wye levels, tall leveling rods, and targets to measure and survey the rolling campus land. They also display an interesting assortment of hat styles.

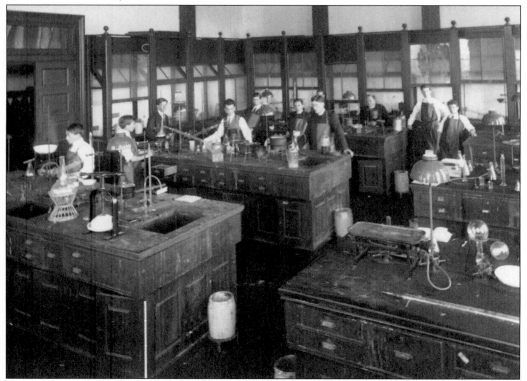

Here is another 1913 class, this time in organic chemistry. At the back of the class overseeing his students' work sits Rev. John J. Griffin, head of the department of chemistry. A very popular teacher, Griffin began his stint with the university when the department was formed in 1895 and stayed until 1922.

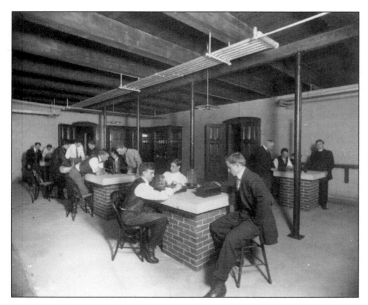

This photograph, also from 1913, depicts a physics class in the basement of McMahon Hall. The students are studying magnetic measurement under the guidance of Dr. Daniel Shea (at the left of the back laboratory table), who departed the University of Illinois to come to Washington, D.C., saying he was "certain that the Catholic University had a glorious future before it." He stayed at the school until his retirement in 1936.

By 1917, when these rules for freshmen were published, undergraduates had developed a number of traditions, including this mild form of hazing. Truxton Circle was about 2 miles south of campus, at the intersection of North Capitol Street and Florida Avenue, thus forcing freshmen to wear their caps (later called "dinks") almost constantly.

Freshman Rules.

1 No Freshman shall appear without wearing the freshman cap, in any place north of Truxton Circle in any company or at any time. The cap shall be gray with red Button.

2 No freshman shall board or alight from a car except at the freshmans gate, and under no circumstances, shall a freshman use the main gate.

3 No freshman shall use the straight path between the main gate and McMahon Hall.

4 No Freshman shall disregard the signs keep off the grass,

5 No Freshman shall use the main entrance to McMahon Hall,

6 No Freshman shall Pass an upper-classman without saluting,

7 No freshman shall refuse to oblige an upper classman.

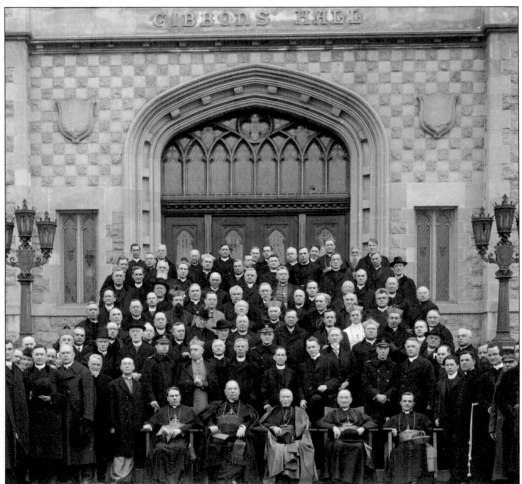

James Gibbons was appointed a bishop by Pope Pius IX in 1868, when he was only 34, making him one of the youngest in the world and giving him the nickname "the boy bishop." Fifty years later, he celebrated his anniversary jubilee at the university. In the picture above, he is seated in the center, in front of the hall that bears his name. An immensely popular religious leader who could draw large crowds to his lectures and sermons, Gibbons was particularly dedicated to the plight of exploited workers, saying at one point, "It is the right of laboring classes to protect themselves, and the duty of the whole people to find a remedy against avarice, oppression, and corruption." He knew many presidents, including Theodore Roosevelt (right), who called him "the most venerated, respected and useful citizen in America."

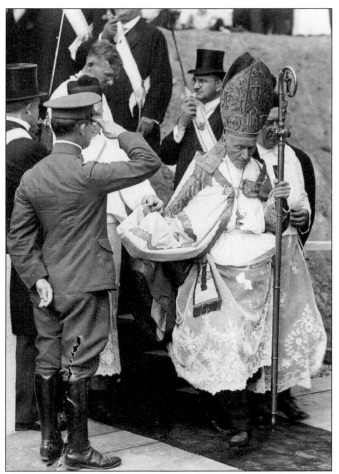

Cardinal Gibbons had many important functions and participated in innumerable public ceremonies. One of the biggest was the one pictured on the left. On September 23, 1920, over 10,000 people gathered on the southwestern corner of the Catholic University campus to see the laying of the foundation stone for the National Shrine of the Immaculate Conception. Here Gibbons prepares to bless the massive granite block, which had travelled from a quarry in Milford, New Hampshire. As he intoned the blessing, the cardinal circled the stone, touching each side with a silver trowel. In the photograph below from 1928, the foundation level is well underway. The crypt church was already operating at this point, having opened in 1924. It was perhaps the lowest, flattest functioning church in the United States and stayed that way for three decades due to funding difficulties.

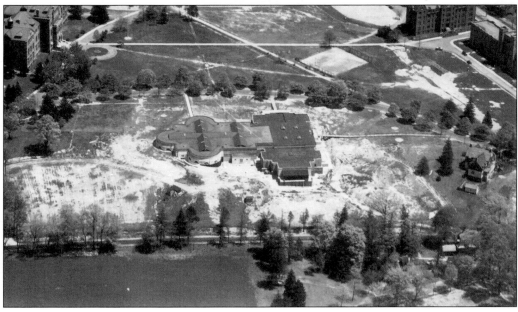

Bishop Thomas Shahan was both the rector of the university and the founder of the National Shrine of the Immaculate Conception. It was his drive that began the project and expanded it into the grand church it is today. His secretary, Rev. Bernard McKenna, became the first director of the Shrine. In 1932, Shahan died and was buried in the crypt, the only person to be so honored.

Salve Regina was the title of a little magazine created by Bishop Shahan in 1914 to raise money for the Shrine. At first, the clerical staff operated out of a room in Caldwell Hall, but it soon needed more space. A small wooden chapel had already been built for them, and in 1920, a new building was put up next to it. Today it houses the university's art department.

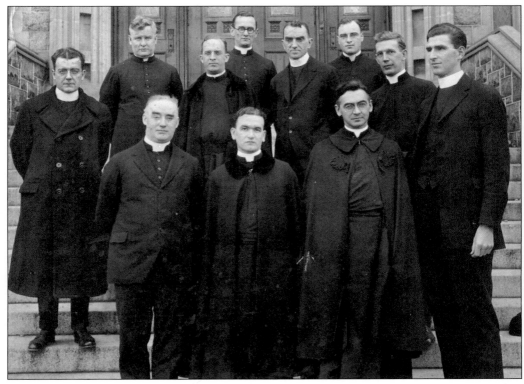

Rowdy students who caused problems had to face this group of stern-looking priests. They are the board of discipline, gathered on the steps of Gibbons Hall in a 1924 photograph. The board was formed in 1915 to keep an eye on the students' "moral character." Students could be expelled for drinking or gambling, and a few were.

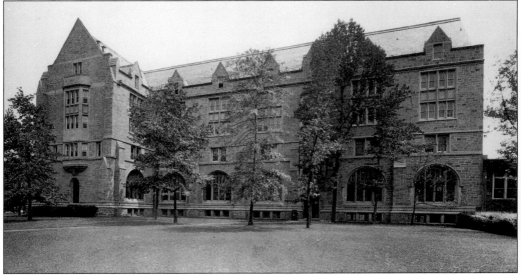

The Society of St. Sulpice affiliated with the university early on, administering Divinity College in 1889. They built their seminary right across Michigan Avenue in 1917 at the urging of Cardinal Gibbons. Originally known as the Sulpician Seminary, after instruction was transferred to Catholic University in 1940, the name was changed to Theological College.

After much agitation from students and faculty members, and with the endorsement of Rector Shahan, plans for a temporary gymnasium were finally put on the drawing board in 1918. Hardly temporary, the building was used as a gymnasium until 1985 and then reconfigured into the Edward M. Crough Center for Architectural Studies. Many large-scale special events took place in the gym, from the 50th anniversary celebration in 1939 to rock concerts in the 1960s and an address from Pope John Paul II in 1979. The gym had some unique features in the sub-level, including a sizable sauna room and a swimming pool (below). A few student divers hit their heads on the dangerously low ceiling.

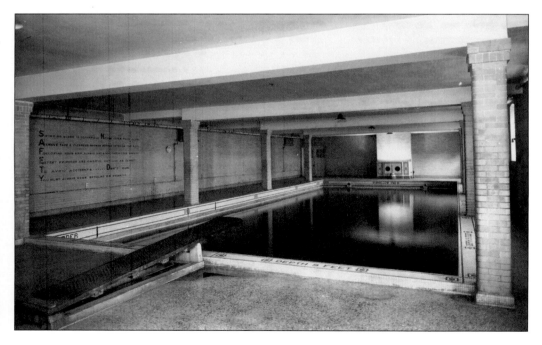

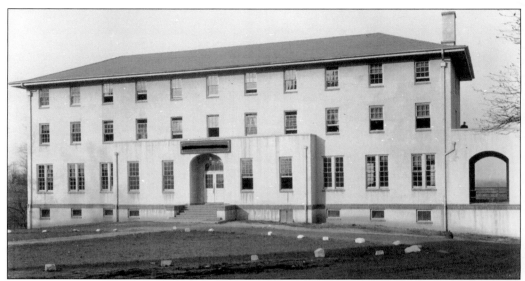

In May 1919, a federally assisted Soldiers' Rehabilitation Camp opened on university grounds. The National Catholic War Council then erected a building for the group next to the gymnasium to provide vocational training. After the war, some veterans were formed into a rehabilitation school baseball team (below) and lived in the building under a subsidized government program. In 1922, the school acquired the building and named it St. John's Hall. It housed a variety of tenants over the years, including campus security; the Fine Arts Council; both the graduate and undergraduate student governments; and the original incarnation of WCUA, the campus radio station.

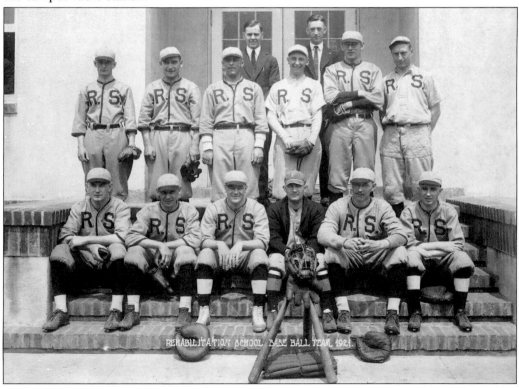

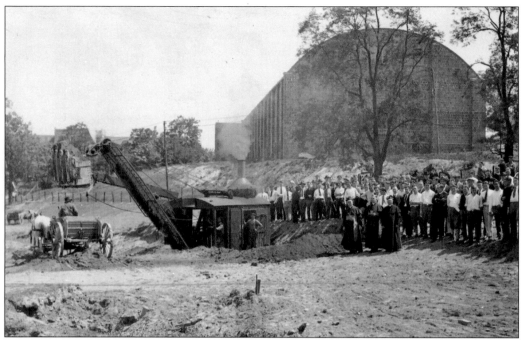

Though the university's rectors had once been adamantly opposed to sports, by the early 1920s that had changed, and Rector Shahan was the biggest booster for a new stadium. He diverted some gifts intended for a new library in order to complete the stadium, saying he expected "the finished Bowl would be our chief financial asset." He had able assistance from engineering professor Louis Crook, who spearheaded the drive and served as the stadium's planner. On May 26, 1923, ground was broken (above). The stadium was dedicated on October 4, 1924, with Pres. Calvin Coolidge in attendance. Below is a photograph taken shortly after its completion.

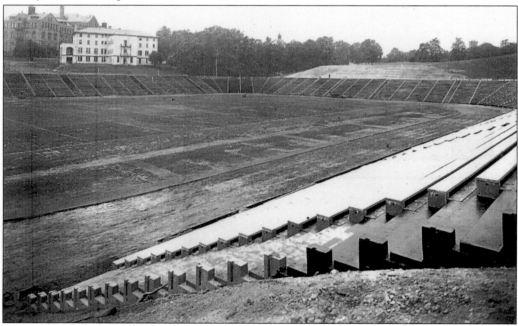

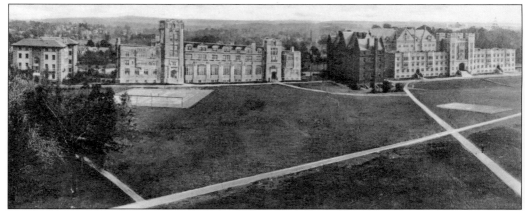

From a 1921 school calendar, this is the row of buildings along Michigan Avenue as seen from the campus side. It is a drawing made from a photograph, though it does idealize one of the buildings. Graduate Hall, in the center between Albert Hall and the Apostolic House, never had its second, larger tower built. In 1959, an east wing was added but canted at an angle and without the tower.

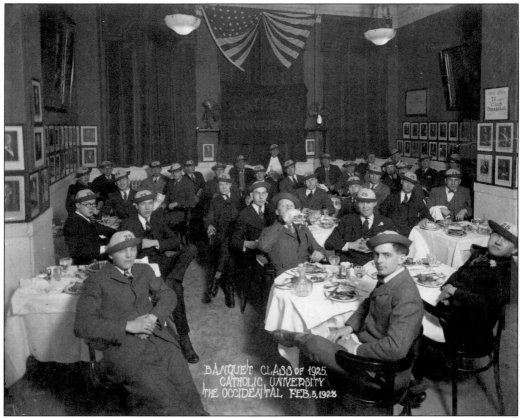

By the early 1920s, Catholic University had reason to celebrate; the financial difficulties from the early part of the century were being surmounted, the number of students had dramatically increased, and Rector Shahan's building program had given the university a distinctly collegiate look and feel. These students are enjoying themselves at a banquet at downtown Washington, D.C.'s Occidental Hotel in 1923.

Three

LITTLE ROME

The Catholic University of America and the neighborhood of Brookland have always been like siblings. They share the same birthday, though they are by no means twins, and they grew up together under the same roof, that of the evolving District of Columbia. Each has influenced and changed the other. As with all siblings, there have been times when one is annoyed with the other, yet the bonds that were formed so early cannot easily be broken.

Especially at the beginning, the flow of influence seemed to come primarily from the university to the neighborhood. Where once this northeastern part of the city contained little but farms and the occasional manor house, suddenly a staggering variety of Catholic institutions began to congregate here, making this quadrant of the city their home. Businesses developed to serve those institutions, and Brookland's commercial district expanded and prospered.

Brookland gained the nickname "Little Rome" early on. It was not simply due to the number of religious buildings but the number of religious men and women who were seen everywhere in the neighborhood. Especially during the summer, when nuns in traditional habits would come to study at Sisters College, Brookland became a festival in black and white, interspersed with brown-robed Franciscans, white-robed Dominicans, and others. Yet the pealing church bells were not just Catholic. The Brookland Baptist Church was built in 1892, and Methodist, Lutheran, and Episcopal churches soon followed.

The Catholic University of America and Brookland remain connected, though they are physically separated by the railroad tracks and the bridges that span them. Plans for new development on both sides of the tracks could be a possible bridge of a different sort—if done well, they could serve to unite the neighborhood and the university in a way they have not been since the early days.

17	258	258	Middleton, E.R.	57	F	W	Keeping House			Maryland						
18			Middleton, E.J.	67	M	W	Civil Criminal Court			Dist Columbia						
19			Middleton, E.J. jr	35	M	W	Supt Rail Road Co			"						
20			Middleton, Virginia	39	F	W				"						
21			Ross, Mary	25	F	W				Maryland						
22			Ross, Lizzie	24	F	W				"						
23			Ross, Jessie	21	F	W				"						
24			Byrnes, Esther	76	F	W				Ireland			/ /			
25	259	259	Smith, Mary	23	F	M	Domestic Servant			Maryland				/ /		
26			Smith, Henry	24	M	B	Farm Laborer			"				/ /		
27			Smith, Rosa	10/12	F	M				Dist Columbia	June			/ /		
28	258	260	Hollins, Eleanor	22	M	M	Domestic Servant			Maryland				/ /		
29			Wade, William	52	M	B	Clerk in Store			Mississippi				/ /		
30			James, Rolfe	24	M	B	" "			Virginia				/ /		
31			Lee, Martha	40	F	B	Domestic Servant			"				/ /		
32	250	261	Brooks, Jehiel	73	M	W	Farmer	10000	2000	Vermont						
33			——, Ann M	63	F	W	Keeping House			Dist Columbia						
34			——, Emily	33	F	W				Louisiana						
35			——, Nicholas	36	M	W	Supt Farm			"						
36			——, Laura	25	F	W				Dist Columbia						
37			——, Frank	24	M	W				"						
38			——, Juliah	27	F	W				Virginia						

This image from the 1870 federal census shows, on line 17, the Middleton family, whose land would become the Catholic University campus. On line 32 is the Brooks family, whose estate would become the neighborhood of Brookland. In 1840, Jehiel Brooks, a colonel in the War of 1812 and a former Indian agent, built this Greek Revival house (below), which he called Bellair, for his new wife, Anne Queen. Brooks died in 1886, and his heirs sold the land to developers the next year. Over the decades, this building served as a Marist school, a sisters college, St. Benedict's Academy elementary school, Northeast Catholic High School, a convent, and currently Washington, D.C.'s public access television station. (Above, courtesy of National Archives; below, courtesy of the author.)

Brookland's initial commercial district evolved here, where the Baltimore and Ohio Railroad tracks crossed Bunker Hill Road (later renamed Michigan Avenue). Its proximity to the university campus is evident in this 1926 photograph. Across the tracks, on the right side of the street, Maloney Hall, the Apostolic Mission House, and Graduate Hall can be seen. On this side of the tracks were shops, a tiny post office (below), and a coal and lumber yard. Students referred to Brookland as "the village." A number of Jehiel Brooks's descendants lived in Brookland and helped the new village grow, including his granddaughter, Agnes Price, who married a Catholic University historian named Leo Stock. The ties between the school and the neighborhood were there from the earliest days. (Above, courtesy of the Historical Society of Washington, D.C.; below, courtesy of Catholic University of America Press.)

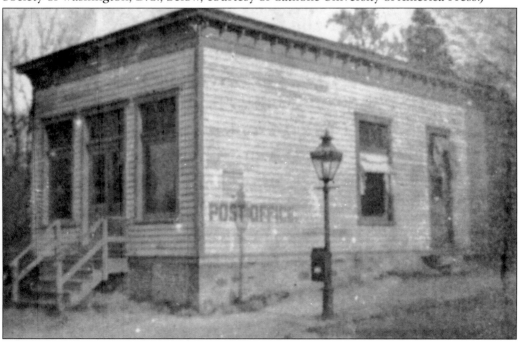

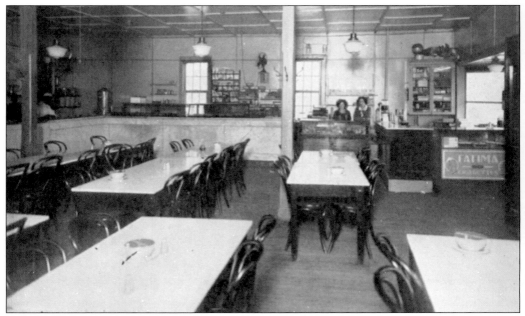

One of the businesses right by the railroad tracks was Hailer's Inn, an enormously popular hangout for Catholic University students. This picture from the 1924 yearbook was titled "We will never forget." Brookland residents also enjoyed the friendly atmosphere provided by Elizabeth and Charles Hailer, who went on to operate a number of local eateries.

In 1937, a bridge was built on Michigan Avenue to span the railroad tracks, as can be seen in this 1961 photograph. Although it did relieve congestion at the grade crossing, it also served to separate the school from the neighborhood rather than tying them closer together. The Brookland Metro stop now sits just to the left of the bridge.

Antoinette Margot was born in Switzerland in 1842 and raised in Lyons, France. During the Franco-Prussian War of 1870, she volunteered for the newly formed International Red Cross. There she met Clara Barton (below), the "Angel of the Battlefield" of the American Civil War, and the two became close friends. When Barton returned to the United States to form the American Red Cross, she asked Margot to join her. Arriving in 1885, Margot, who had become an ardent convert to Catholicism, worked with Barton briefly, but there were problems. Margot found the Barton household noisy and confusing, and Barton, a Universalist, found Margot's religious zeal disturbing, saying "nothing but a priest and a confessional can make her happy." The two split with some bitterness. It was then that Margot moved to Brookland looking for ways to serve her new church.

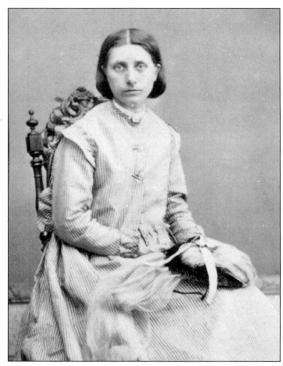

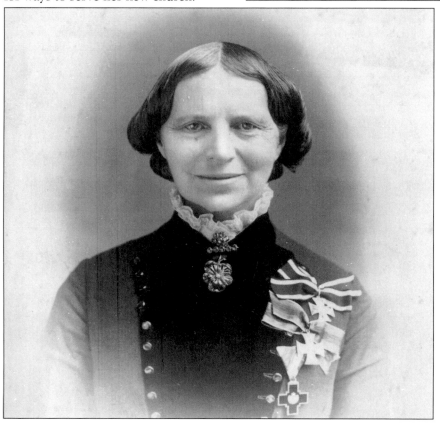

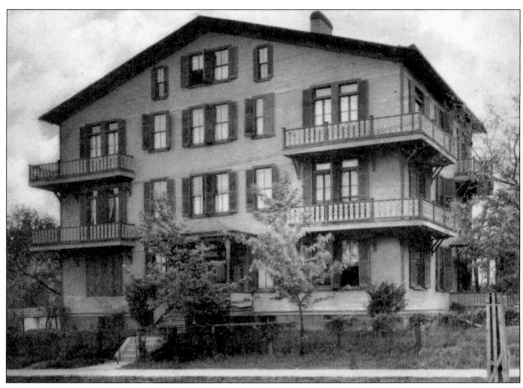

In 1889, with money from her father, Antoinette Margot and her friend, Leonide Delarue, built a large frame house near the Brooks mansion. They called it Theodoron, which means "God's gift." The two women then sought out Rev. Henri Hyvernat (below, center), Catholic University's professor of Semitics and Egyptian languages and one of the school's original faculty members. They asked for his help obtaining permission from Cardinal Gibbons to hold masses at their home for the Brookland community. Also a native of Lyons, Hyvernat bonded with Margot, and they began to work together. The first mass was said in Theodoron in 1891, with Hyvernat acting as the unofficial pastor. He held the first of many fund-raisers in 1892 and used the proceeds to buy a tract of land at Twelfth and Monroe Streets. (Above, courtesy of John Feeley.)

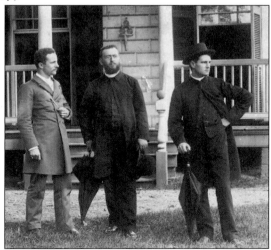

Plans were made to build a church on the land Father Hyvernat had purchased. On June 13, 1896, St. Anthony's feast day, the new wood-frame church was dedicated. Cardinal Gibbons suggested it be named St. Anthony of Padua in honor of Antoinette Margot. She built a new home directly across the street from St. Anthony's Church and called it Villa Marie (below). She lived there with Leonide Delarue for the rest of her life, next door to Hyvernat. The two women tended the St. Anthony's sanctuary and took care of numerous tasks there, even teaching Latin to generations of altar boys. Margot became a fixture in Brookland, often going out for strolls in her customary blue attire. Antoinette Margot died in 1925. (Above, Courtesy of Library of Congress.)

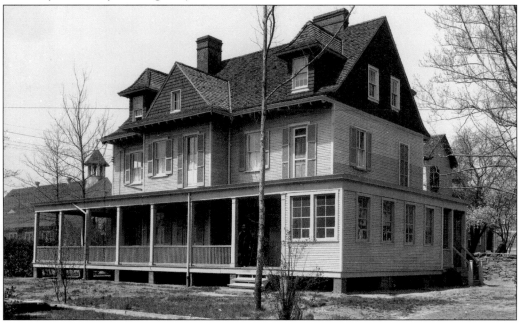

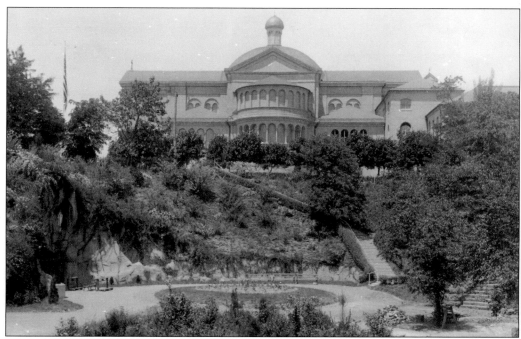

The Order of St. Francis was one of the earliest religious groups to affiliate with the university and establish a presence in Brookland. In 1897, Rev. Charles Vassani organized a commissariat to purchase the McCeeney estate, and within two years, they had erected an impressive Byzantine monastery with Romanesque elements surrounded by beautiful gardens, grottoes, and replicas of sites in the Holy Land.

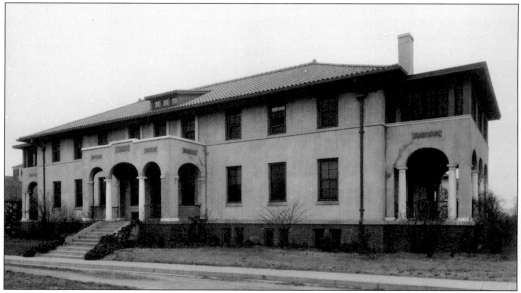

Other communities of Franciscans also settled in Brookland. In 1917, the School Sisters of St. Francis built the St. Francis House of Studies on the campus of the Sisters College at Eighth and Varnum Streets. In the decades since, it has had a number of different owners, including the Ursuline Sisters and Catholic University, which traded it for the Marist College building on the main campus.

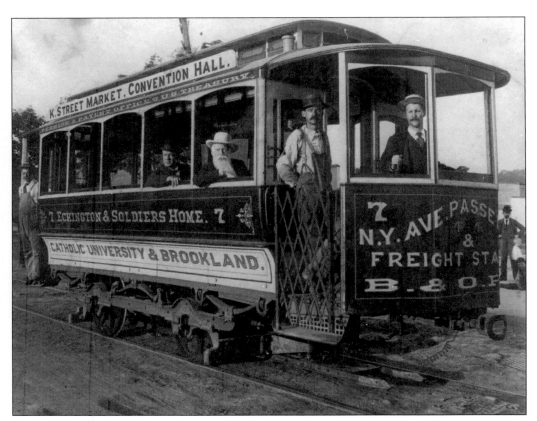

For their first few years, both the university and Brookland relied on the Baltimore and Ohio Railroad for transportation. That changed in 1889, when the Eckington and Soldiers' Home Railway Company brought streetcar service to Fourth Street and Michigan Avenue. In 1894, the line was extended down Michigan to the railroad tracks. The big change came in 1910, when a bridge across the tracks on Monroe Street allowed streetcars into the heart of Brookland. The community had raised money for the bridge and joined with Catholic University to petition Congress to permit streetcar service. The picture to the right, from 1916, shows the tracks on Michigan Avenue in the foreground, then going down Monroe Street. The smoke is from a locomotive just passing beneath the new bridge. (Above, courtesy of Library of Congress.)

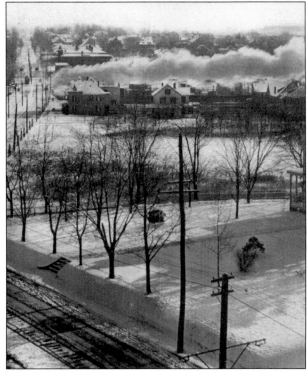

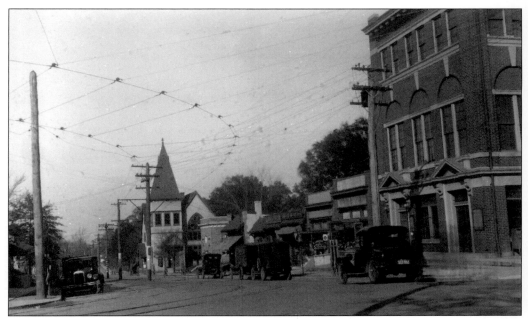

With the arrival of the streetcar, the commercial center of Brookland shifted from near the railroad tracks to Twelfth Street, and it began to develop quickly. This photograph from 1925 looks north from the intersection of Monroe and Twelfth Streets. The church at the next intersection is the Brookland Baptist Church, which burned in 1926. The overhead streetcar wires are plainly evident. (Courtesy of the Historical Society of Washington, D.C.)

The Marists had another building near campus in addition to their college. This is the Marist Seminary, just around the corner from the university. For many years, a famous painting, *The Assumption of the Blessed Virgin* by Spanish painter Bartolome Murillo, hung in the chapel there. It is now on permanent loan to the National Shrine of Mary, Queen of the Universe, in Orlando, Florida. (Courtesy of Library of Congress.)

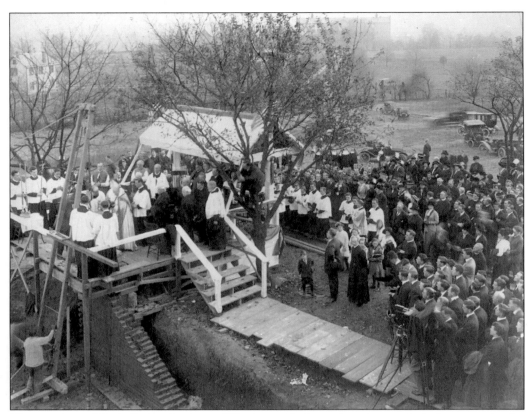

The number of Catholic institutions affiliating with the university continued to grow in the early part of the 20th century. In 1913, the cornerstone was laid for St. Paul's College, just a little south of the CUA campus. The Paulist Fathers had been founded in 1858 by four former Redemptorist missionaries, all of whom had converted from Protestantism. Led by Rev. Isaac Thomas Hecker, the Paulists wanted others to follow that path and made the conversion of Protestants their principal work. During its first 25 years, the majority of Paulist Fathers were converts. The Paulist College was finished and opened its doors in 1914. (Below, courtesy of Library of Congress.)

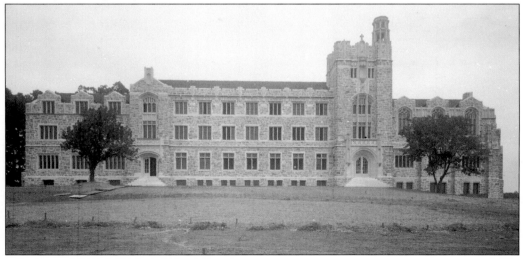

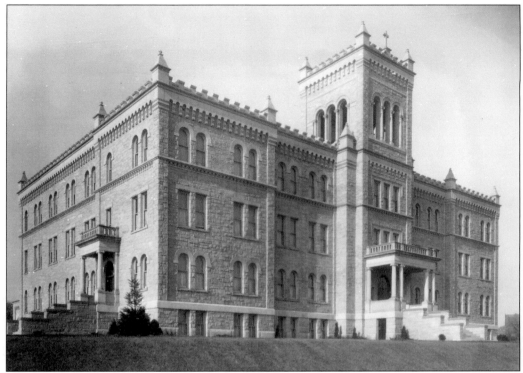

Adjacent to St. Paul's College is the home of the Redemptorists. Holy Redeemer College, for graduate student priests, was dedicated in 1934, the year this photograph was taken. This beautiful building was designed by Anthony F. A. Schmitt. It is faced with granite ashlar and Indiana limestone, with substantial terra-cotta trim.

Not every Catholic school in Brookland was directly associated with Catholic University, though there was usually some sort of connection. St. Anselm's Priory was begun by four members of the Order of St. Benedict in 1924. Under the leadership of Rev. Thomas Verner Moore, a professor at CUA, they began a four-year high school dedicated to scholastic excellence. It continues to operate today, though the name has been changed to St. Anselm's Abbey School.

St. Gertrude's School of Arts and Crafts was spearheaded by Rev. Thomas Moore of Catholic University and St. Anselm's Priory and is located nearby on Sargent Road. Under the direction of four Benedictine sisters, St. Gertrude's was one of the first schools in the country to offer schooling for developmentally challenged children. The building is now part of the Boys Town organization.

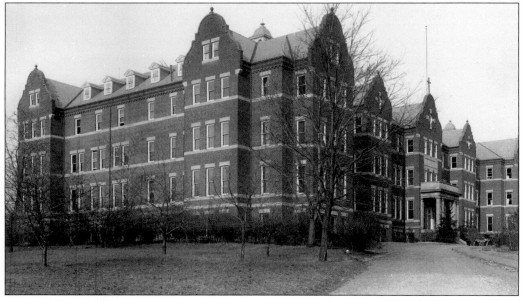

Some of the buildings and organizations that once were all over the neighborhoods around Catholic University have disappeared. St. Vincent's orphanage and school, just a few blocks away from St. Paul's College, was originally the estate of Salmon P. Chase, U.S. Secretary of the Treasury under Abraham Lincoln. Called Edgewood, the home gave its name to a neighborhood adjacent to Brookland. The city acquired the property in the 1950s, and the building was demolished.

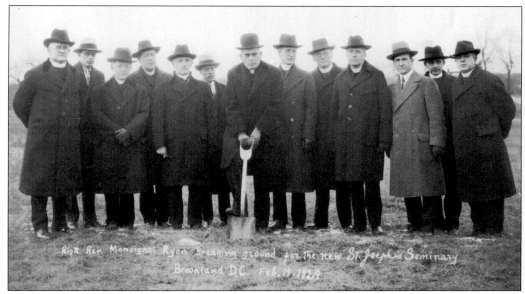

Right Rev. Monsignor Ryan Breaking ground for the new St. Joseph's Seminary Brookland D.C. Feb. 19. 1929.

The Society of St. Joseph of the Sacred Heart, known as the Josephites, traces its roots back to 1871, when a small group of priests left their home base of London to come to the United States with the primary mission of evangelizing African Americans. Soon they had four parishes in Washington, D.C., that ministered to black Catholics. In 1929, they broke ground for a new seminary in Brookland. Msgr. James H. Ryan, the rector of Catholic University, is holding the shovel. The finished building was dedicated in 1930, with Cardinal William O'Connell of Boston officiating, assisted by university chancellor Archbishop Michael Curley. (Below, courtesy of the author.)

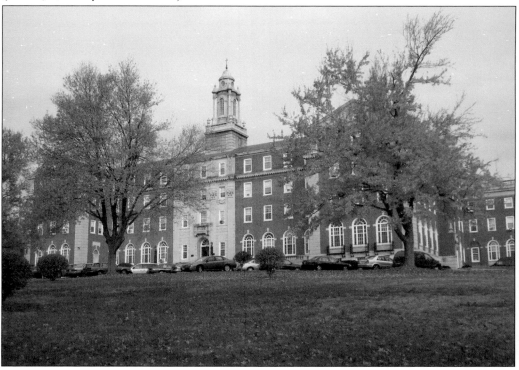

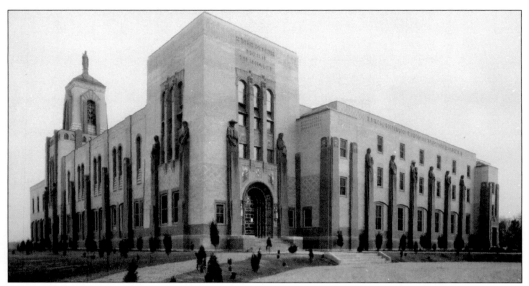

At one time, CUA was practically the only place in the country for Catholic graduate education. As that changed over the decades, so did the number of houses of studies around the university. Some have left, such as Holy Name College (above), which opened in 1930 under the Order of Friars Minor. It is now the Howard University School of Divinity.

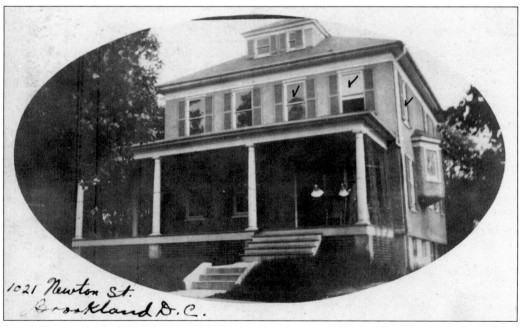

1021 Newton St.
Brookland D.C.

In addition to the great number of Catholic institutional buildings around the neighborhood, many of the larger residences were occupied by members of religious orders. A good example is this house, seen in a photograph album from 1911. Sisters of Mercy, in their first year at Sisters College, then occupied it. At different times, it has also housed the pastor of St. Anthony's and the Spanish Augustinian College.

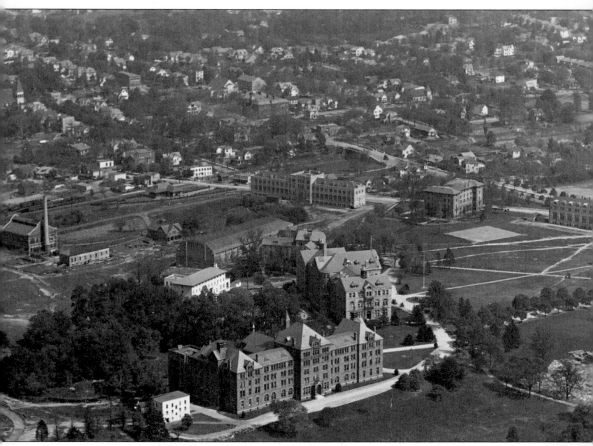

This aerial photograph from 1923 perhaps best shows the physical relationship between Catholic University and Brookland. It cannot depict the psychological relationship, however. That has changed and evolved over the years. At one time, the Catholic influence was seen and felt everywhere in the neighborhood. It is still strongly present, but not at the level it once enjoyed. Other factors—political, municipal, and economic—have all grown in importance since the neighborhood was founded. Still the school and the neighborhood often work together on important civic issues, such as the battle over the North Central Freeway in the early 1970s. The eight-lane highway was supposed to run through Brookland right next to the railroad tracks, destroying many houses and essentially cutting the neighborhood in two. CUA joined with Brookland to oppose the freeway and eventually prevailed. In over a century of growth, Brookland has developed into a feisty, independent-minded part of the broader city of Washington, D.C.

Four

COMING OF AGE

Despite the economic ravages of the Great Depression, enrollment at CUA grew by 70 percent during the term of Rector James Ryan (1928–1935). Much of this was due to Ryan's reorganization of the university.

In the beginning, Catholic University followed a European structural model, and Ryan felt the school had to adapt along more American lines. Deans were given more authority, the school of arts and sciences was split into a graduate school and a college, and a school of engineering was created. The reorganization was effective, but not without difficulties and opposition, particularly from the school of sacred sciences, which felt its independence was being stifled. The graduate school of arts and sciences quickly became the largest school in the university, spearheading an overall increase in the number of graduate students.

In addition to academics, Catholic University was dealing with sensitive social issues. In 1889, the school's first rector, Bishop John Keane, had freely admitted black students, and their numbers had grown over the years. By 1919, that open attitude had changed, and African American students were excluded completely. It took 17 years to overturn the ban, but in 1936, CUA once again admitted black students, making it the first "white" school in the District of Columbia to do so during that era.

The admission of women was also something the university wrestled with for many years. Trinity College and Sisters College provided undergraduate education, but women interested in Catholic graduate studies had few places to turn. The first woman allowed on campus for graduate studies was Sr. M. Inez Hilger, in 1924. The university was open to all women religious in 1928. Shortly after, laywomen were admitted (for graduate work only) in the arts and sciences and professional schools. The first undergraduate women were allowed limited access beginning in 1932.

The Catholic University of America's growing pains mirrored those in the rest of the nation, but like the country, it continued to evolve throughout World War II and into the 1950s.

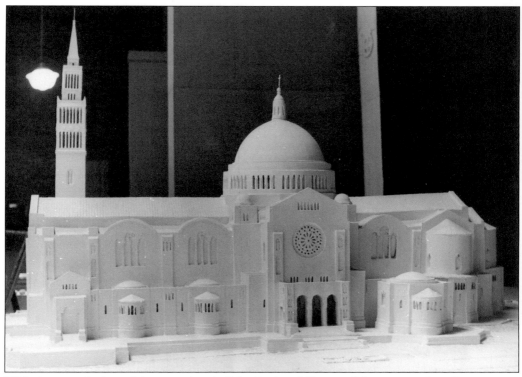

With the completion of the crypt level of the National Shrine of the Immaculate Conception, campus architecture was about to undergo a change. While the first design concept for the Shrine was Gothic, what had finally been decided upon was more Byzantine-Romanesque, as can be seen from this model (above). A new library building, long considered a necessity on campus, was the first to be affected by the change. The university turned to the architectural firm of Murphy and Olmstead to design a library that would complement the future Shrine as well as the rest of the campus buildings. They chose to use the Italianate Revival style, and the result was an elegant, refined building (below) that drew much praise from the country's architects when it was erected in 1928.

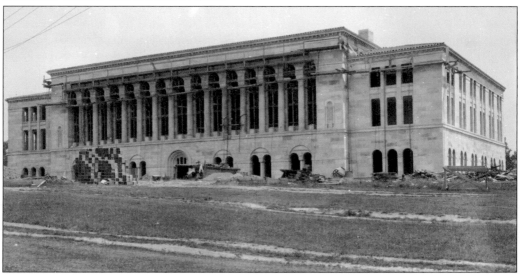

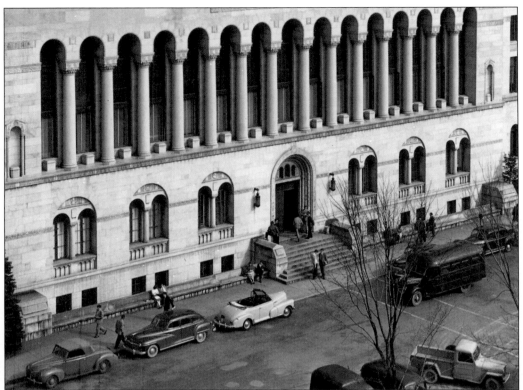

John K. Mullen of Denver donated the money for the library, but it had a number of strings attached, including the demand for 10 annual scholarships to Denver-area students. His donation did not cover the entire construction, however. The rear of the building, where the stacks are located, had to wait until 1958 to be completed. Nonetheless, the university finally had a worthy place to store its own collection as well as three significant special collections—the Portuguese-language library of Manoel De Oliveira Lima; the book collection of Archbishop Michael Curley; and the Clementine Library from Italy. The front of the library quickly became a convenient place for students to gather and catch the campus shuttle bus (above) after they had checked out their books from the circulation desk (below).

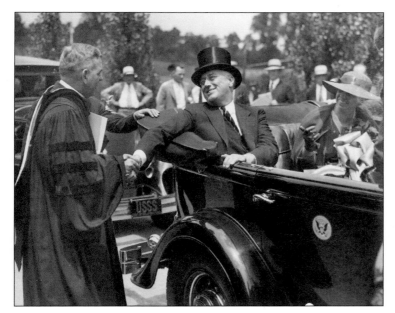

After the resignation of Rector Thomas Shahan in 1928, Msgr. James H. Ryan was chosen as his successor (here with Franklin and Eleanor Roosevelt in 1933). Where Shahan had become known as the "builder rector," Ryan headed in a different direction. "A university is a society of men, not buildings," he wrote in 1930. He focused on bolstering the quality of the faculty and their scholarship.

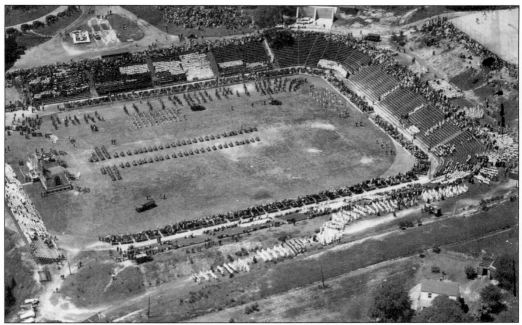

The same year that Franklin Delano Roosevelt was elected, 1932, saw this military mass at the university stadium. It was held to celebrate the bicentennial of George Washington's birth. Rector Ryan was not solely devoted to scholarship; he was also a great lover of college sports and brought the university into big-time athletics, particularly in football.

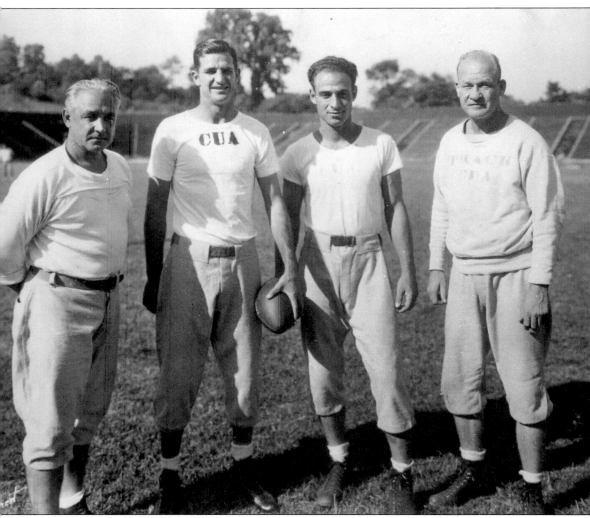

Arthur "Dutch" Bergman was the head coach of Catholic University's football team. Brought in by Rector Ryan, Bergman was paid a salary higher than any faculty member, causing considerable consternation, though his winning record over his decade at the school caused an equal amount of joy. In this photograph from 1939, Bergman (left) poses with his fellow coaches, two of whom were currently stars with the Washington Redskins football team. Standing next to Bergman from left to right are "Slingin' " Sammy Baugh, Redskins quarterback and future hall of famer; Wayne Millner, Redskins end; and Forrest Cotton, who also coached CUA's basketball team. Baugh was not a full-time coach but did come out a few afternoons during the season to instruct CUA's quarterbacks. After his term at the university, Bergman went on to coach the Washington Redskins for a single season in 1943. Although they started strong, they lost their last three games, then lost in the National Football League championship, and Bergman was dismissed.

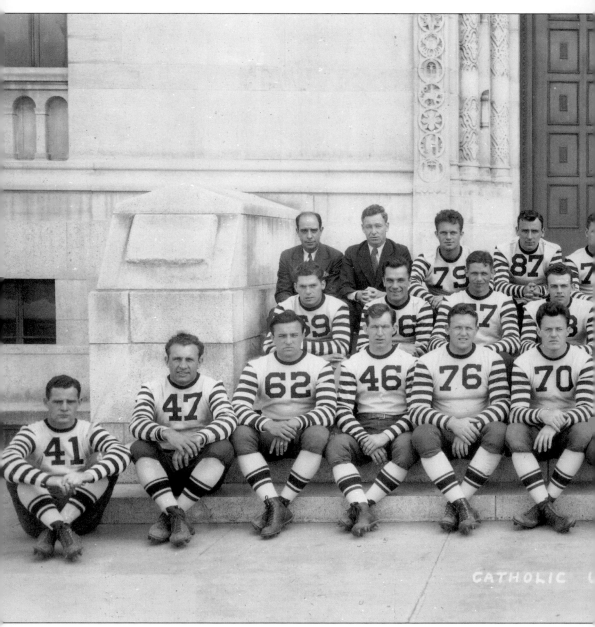

After a season record of 7-1 in 1935, Catholic University was invited by the Orange Bowl Committee to represent the north at the second Orange Bowl in Miami. The University of Mississippi represented the south. CUA jumped out to a 20-6 lead, but then Ole Miss came back strong, scoring 13 points late in the game. A missed point after touchdown for Mississippi was the critical difference. Three thousand fans awaited the victorious Flying Cardinals when

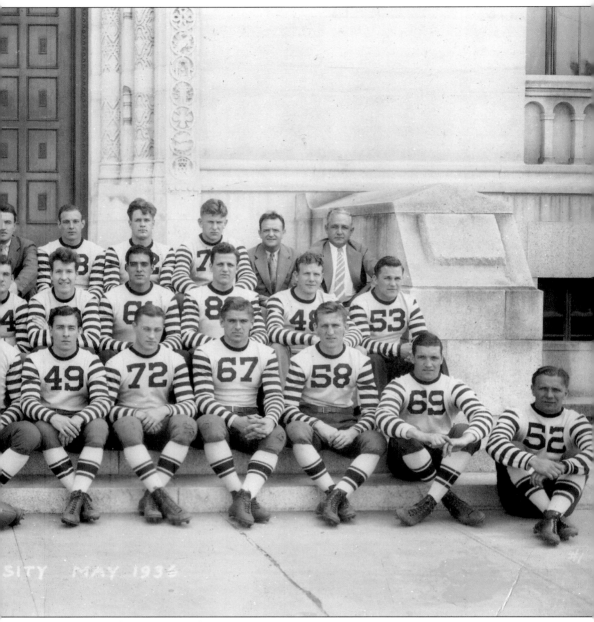

they arrived at Union Station, followed by a victory parade down Pennsylvania Avenue. The *Washington Post* reported that President Roosevelt unwittingly joined the parade when it jammed traffic in front of the White House as he was going to church. Here the team poses on the steps of Mullen Library.

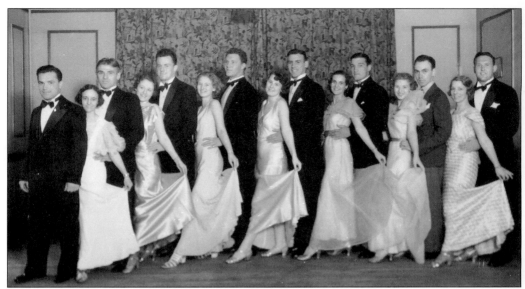

Not surprisingly, the university community was very excited about the Orange Bowl win. The alumni decided to throw a special banquet in the team's honor, which they did on January 16, 1936, at the Willard Hotel in Washington. The original caption for this photograph gives no information about the young ladies accompanying the football players.

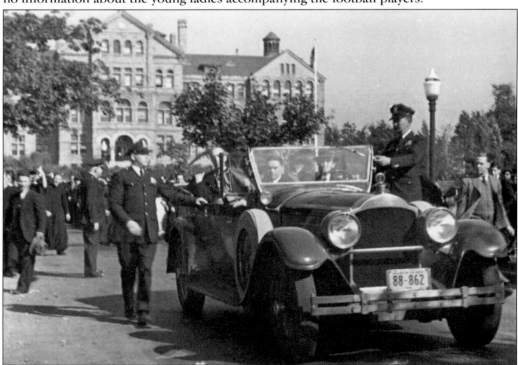

On October 22, 1936, Cardinal Eugenio Pacelli, the Vatican's secretary of state, came to Catholic University as part of a whirlwind tour of the United States. He was the highest-ranking Vatican official to visit the States up to that time. His itinerary also included stops in Los Angeles, Chicago, Boston, and Hyde Park, New York, to meet President Roosevelt. In 1939, Pacelli became Pope Pius XII.

Although he did not visit again in person, Pope Pius XII did send a personal message to this gathering for the 50th anniversary of CUA's founding, held in the gymnasium on November 13, 1939. Lights were dimmed and a spotlight shone on the portrait of the Pope as he spoke in English in a special broadcast from Vatican City, lauding the work of the university. Also on that day, Rev. Henri Hyvernat, the last surviving member of the original faculty, received an honorary doctor of laws degree. Later in the afternoon, a cornerstone was laid for a new building on campus. Archbishop Michael Curley, the university's chancellor, blessed the stone that would anchor the new residence hall for priest faculty (below), named in Curley's honor.

Funding for engineering programs had always been difficult for the school, given the cost of technology. As early as 1920, Rector Shahan had requested a $1-million dollar grant from the Carnegie Corporation but was denied. Another problem was faculty devoting too much time to outside work, which eventually led to a brief loss of accreditation for engineering programs. In this 1939 photograph, two electrical engineering students work at an experimental telephone set-up.

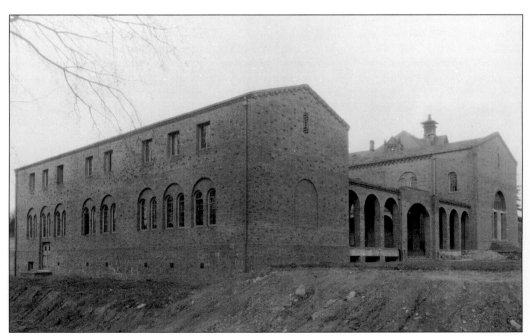

Ward Hall was built in 1930, intended as the home for a new school of music. Problems delayed the music program, so for its first years, this building was used for nursing education and then by the new speech and drama department. That department, under the direction of a charismatic young Dominican priest, Rev. Gilbert Hartke, was to have a profound and long-lasting effect on the university.

Father Hartke ran the speech and drama department from its inception in 1937. He quickly gathered a talented faculty that included Dr. Josephine Callan and Walter Kerr. In this 1938 photograph, Hartke poses with Broadway legend George M. Cohan, Josephine Callan (far left), and graduate drama students. A year later, Walter Kerr and Leo Brady wrote a show based on Cohan's life called *Yankee Doodle Boy*. Cohan had turned down a generous offer from MGM for movie rights to his life, but when Josephine Callan, an old family friend, asked for permission for Catholic University to do the show, he graciously agreed. It was a huge success and eventually led to the movie *Yankee Doodle Dandy*, starring James Cagney (seen below with Hartke), who won an Oscar for his performance.

Walter Kerr had just received his degree in drama from Northwestern University and was looking for a teaching position. He wrote Father Hartke, who dispatched Josephine Callan to meet him. "I fell head over heels," Kerr later recalled. "We spent the entire rest of the day talking and couldn't stop. She was completely charming. We became thick as thieves. I wanted to be wherever Josephine was." Josephine McGarry Callan had first met Hartke in 1937. She had been a distinguished teacher of elocution at Northwestern University before her marriage to a wealthy attorney. With her husband's death in 1936, she was looking for a way to get back into her field. Becoming professor of drama at CUA seemed a good fit. In this picture from 1944, Kerr directs some students in *Sing Out Sweet Lord*, while Callan (left, standing) observes. Walter Kerr taught at Catholic University for seven years and was an enormously popular drama instructor. He went on to a long career as theater critic for the *New York Times* and won the Pulitzer Prize for criticism in 1978.

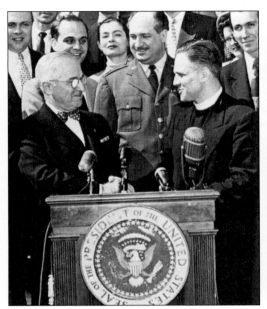

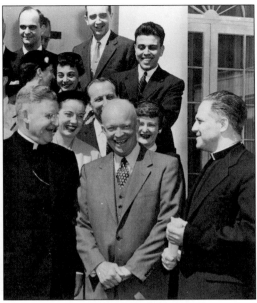

Father Hartke knew everyone, not only in theater and film but in politics as well. He had enormous charm and used it to the advantage of his drama program. Hartke was an advisor on the arts to Presidents Eisenhower and Kennedy and was named to the National Council on the Arts by President Johnson. He often brought his students to the White House when they were about to go on tour. Clockwise from top left, he is seen with President Truman, President Eisenhower (with Rector Bryan McEntegart), and President Kennedy (with student Carol Keefe) in 1963. As they were leaving the Rose Garden that day, Kennedy asked Hartke to give him a parting line from Shakespeare. Hartke's mind went blank, but fortunately Carol Keefe jumped in to say "Mr. President, the quality of mercy is not strained!" and saved the day.

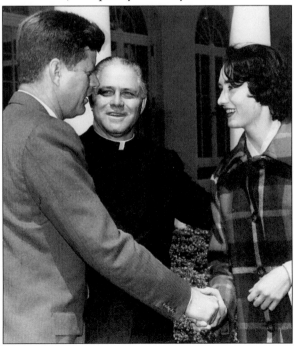

Dorsey Griffith was appointed track coach at CUA in 1928. Track enjoyed nowhere near the popularity of football or baseball, and Griffith struggled. He managed to build a wooden track in the 1930s, but that burned. Students put on a show called *The Albert Hall Frolics* to raise money for a new one, which was built along Brookland Avenue between Zimmerman Hall and the power plant in 1940.

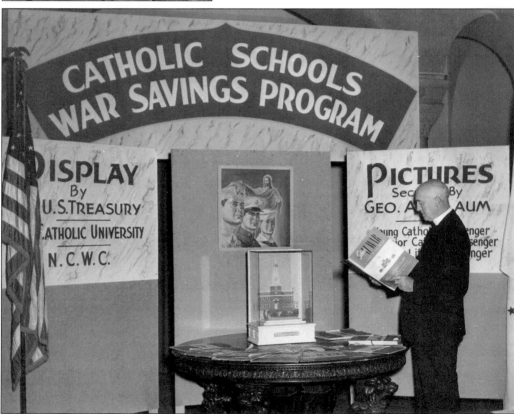

The outbreak of World War II had an effect on the university, just as World War I had. Various committees were quickly created to deal with a number of issues—military affairs, military training programs, and promotion of war bonds and savings stamps. In the above photograph, Rector Patrick McCormick looks over a campus display from the U.S. Treasury Department.

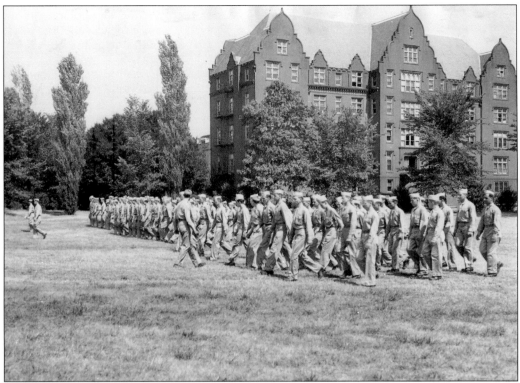

Enrollment fell during the war years from 2,505 students in 1940 to 1,810 in 1943. In that year, some of the lost tuition was made up by the school's housing of a unit from the U.S. Army Specialized Training Program. In the above photograph from August 14, 1943, the 1517th unit arrived to start training and immediately went into formation and marched in front of Albert Hall. One of the most significant things the school did during the war was to buy the airplane seen in the photograph below, taken in 1944. Named *The Flying Cardinal*, this Mustang P-51 was purchased through $85,000 in war bond subscriptions from students and faculty.

Boxing, a popular sport since the early 1930s, was huge during the war and postwar years. While a student in 1924, Edmund LaFond was the captain of Catholic University's first intercollegiate boxing squad. In 1931, he became coach of the university team and stayed in that position until 1955, never having had a losing season. He also produced two national champions. His boxers were known as "Eddie's Boys." In the photograph at right from 1949, he demonstrates some of the finer techniques of the sweet science to student boxer Dick Trumper. In the photograph below, Trumper puts those lessons to the test in an intercollegiate match.

There may have been fewer students during the war years, but some traditions, like freshman hazing, did continue, as can be seen by the abundance of dinks (red and black caps) in this picture from that era. This is the university dining hall, which closed when the Pryzbyla Center was opened in 2003.

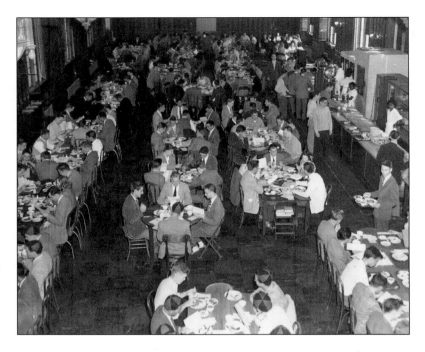

Though graduate women had started to be admitted to the university in 1928, the question of undergraduate women remained a thorny one. It was nursing students who eventually broke the barrier in 1932, when in addition to their professional nursing courses they were allowed into classes in other arts and sciences departments. This picture is from 1954, when nearby Providence Hospital was under construction.

Though the admission of women occurred piecemeal over a period of 15 years, by 1945, there was a need for a women's dormitory. Ryan Hall, named for Rector James Ryan, was the first. Originally slated to be built along Harewood Road, it was changed to Brookland Avenue, probably because the first location would have been too close to the student priests in Caldwell Hall. Here Rector McCormick blesses the cornerstone.

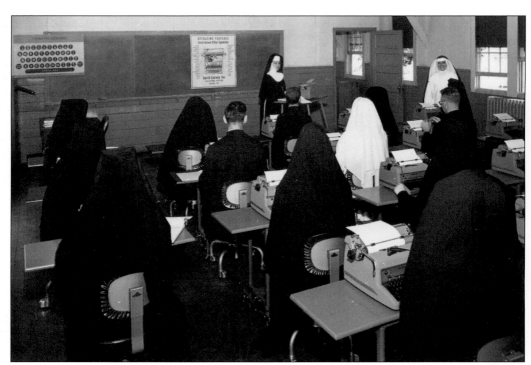

What had been unthinkable in the university's early years—women undergraduates in classes with men—was now beginning to happen. This is a typing class in a business education program with nuns and a few priests. Sister Alexius shows the students the ins and outs of their Smith Coronas. Women undergraduates were not fully incorporated into all levels of the university until the early 1950s.

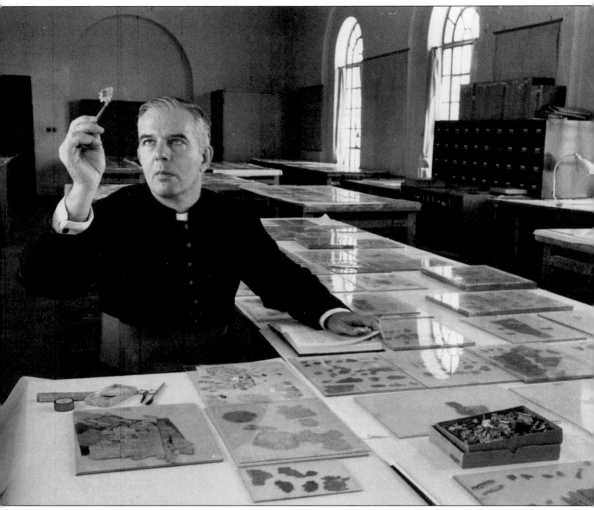

The 1947 discovery of fragments of ancient parchment manuscripts in caves near the ruins of Khirbet Qumran on the shores of the Dead Sea caused an archeological sensation. The Dead Sea Scrolls, a collection of 2,000-year-old Biblical and non-Biblical texts, are considered among the most important finds of the 20th century. In 1953, Rev. Patrick Skehan, then head of Catholic University's Semitics department, was one of the eight scholars—and only two Americans—appointed to the distinguished international Dead Sea Scrolls editorial team. In this photograph from 1955, Skehan, by then a monsignor, examines a scroll fragment at the Palestine Archeological Museum in East Jerusalem. Translating the Dead Sea Scrolls was a time-consuming process that caused great aggravation among those scholars without access to the manuscripts. Skehan issued preliminary publications of the most significant texts in his control but died in 1980, before their final publication.

Rev. Fulton Sheen was one of the most influential Catholics of the 20th century. The above photograph is from 1920, his first year at Catholic University. After completing his studies, he taught theology and then philosophy at CUA from 1926 to 1950. In 1930, he began his radio program, *The Catholic Hour*, which drew an audience in the millions. But it was his work on television that truly imprinted him on American culture. *Life is Worth Living* began in 1951 and was broadcast on Tuesday evenings opposite the enormously popular comic Milton Berle. Surprisingly Sheen held his own in the ratings, winning an Emmy award in 1952. In accepting the award, Sheen remarked "I feel it is time I pay tribute to my four writers—Matthew, Mark, Luke and John." He often returned to campus to address students (below).

Five

TOWARD THE FUTURE

Heading toward the 21st century, Catholic University continued to grow and adapt to the times, from the relatively staid Eisenhower era through the period of change and growth that symbolized the Kennedy/Johnson years to the Nixon period of angst and protest.

The issues then were about war and peace, freedom and servitude, knowledge and ignorance, and life and death. In the years since, the names and details have changed, and new events have occurred, yet the broad issues remain. The Catholic University of America and its administrators, faculty, and students also have changed, as they must.

Of course, that has been the challenge for Catholic University from the beginning: to grow and adapt to changing ideas, modes of thought, and opportunities without forgetting its core beliefs and without losing its soul. Its success can perhaps best be judged by going back to the beginning and reading the words of Bishop John Lancaster Spalding when the cornerstone for Caldwell Hall was laid in 1888. He spoke that day of his ideal university, an incubator of thought and learning, then continued: "The good we do men is quickly lost, the truth we leave them remains forever, and therefore the aim of the best education is to enable students to see what is true and to inspire them with the love of all truth. Professional knowledge brings more profit to the individual, but philosophy and literature, science and art, elevate and refine the spirit of the whole people, and hence the university will make culture its first aim, and its scope will widen as thoughts and attainments of men are enlarged and multiplied. Here, if anywhere, shall be found teachers whose one passion is love of truth, which is the love of God and man."

The Catholic University of America, from its rocky beginnings to its stature in the 21st century as one of the country's leading educational institutions, has attempted not just to live up to those words but to assimilate them into its very essence.

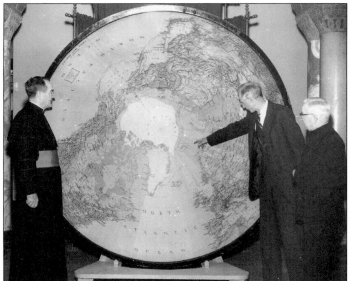

Catholic University takes over the world? In actuality, this is a concave partial globe presented to the university by the U.S. Army Map Service. Examining the globe in this picture from the late 1950s are, from left to right, Rector William McDonald; Dr. Kenneth Bertrand, head of the geography division; and Rev. Artheme Dutilly of the university's Arctic Institute.

The Brennan Rifles, an offshoot of R.O.T.C.—the Reserve Officers' Training Corps—was not a shooting squad. It was a trick drill team, performing intricately synchronized marching maneuvers while spinning and tossing its rifles, which were M-1 Garands with the firing pins removed. The squad competed against other schools in the mid-Atlantic region. In this 1956 photograph, the squad practices in the Catholic University stadium for an upcoming match.

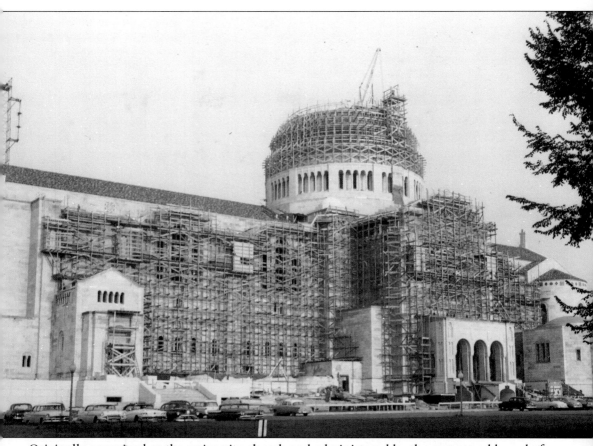

Originally conceived as the university church and administered by the rector and board of trustees, the National Shrine imposed a significant fiscal burden on the school. The Shrine's first director, Msgr. Bernard McKenna, operated as independently as possible, which caused considerable friction with the university's financial controllers. McKenna was forced to resign from his position in 1933. Fifteen years later, the Shrine formally separated from the university and became the National Shrine of the Immaculate Conception, Inc. Catholic University deeded the land to the Shrine and control migrated from CUA's board to the American bishops, who instituted a donation quota for the Shrine from every diocese in the country. Between 1954 and 1958, construction proceeded quickly, and the National Shrine of the Immaculate Conception was dedicated on November 20, 1959, with Cardinal Francis J. Spellman presiding.

The Catholic University of America continued to build in the next decade, as can be seen in this 1961 photograph of Gowan Hall's construction. Gowan (nursing), the McCort-Ward building (biology), and Pangborn Hall (engineering and architecture) were all built at the same time in a very utilitarian style. Two equally plain dormitories were also erected along Monroe Street around this time.

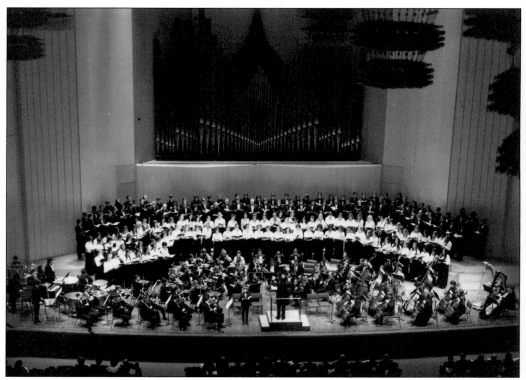

On February 11, 1972, the Catholic University orchestra and chorus performed at the Kennedy Center. It was the first time a college group had performed on its own there (that is, without the National Symphony or another professional group accompanying). The program included Ralph Vaughn Williams's *Mass in G Minor* and Leonard Bernstein's *Chicester Psalms*.

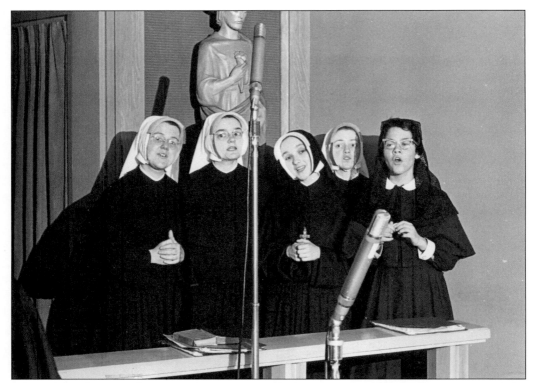

When the Religious of Jesus and Mary, some of whose members studied at CUA, needed a new dormitory, they decided to sing for the money. The Jesus and Mary Choral Group, five of whom are seen in this 1963 photograph performing on campus, eventually recorded four albums for Columbia Records. They had a clever marketing technique—telling disc jockeys who played their records that they would put them on a "prayola" list.

The university's home-grown singing group, the Cardinalaires, began as an all-male choir in the 1950s but quickly expanded to include women. In this photograph from 1967, they are about to embark on a tour of military bases in Newfoundland, Labrador, Iceland, and Greenland. Faculty advisor Msgr. Donald Reagan can be seen in the second row at right.

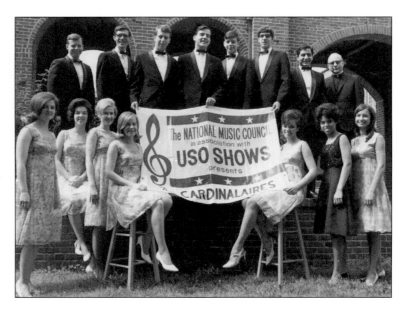

H. Emerson Meyers was an accomplished pianist and composer who was very active in the Washington, D.C., arts scene. He joined the faculty of the Catholic University music school in 1943, and in 1964, he opened one of the first electronic music studios in the country. He had become interested in the experimental form during the 1930s. "I couldn't stand the sounds when I first came into contact with them," he once said. "There was no direction, no form; they were just sensational noises, not music. In fact, I disliked them so much that electronic music aroused my curiosity, and I decided to look into it." Meyers sometimes incorporated taped sounds and odd instruments into his own compositions. He brought one of the first Moog synthesizers to his studio in 1967 (below).

Clare Fontanini was chairman of the Catholic University art department from 1947 to 1968. A noted religious sculptor, she worked primarily in wood and stone, though she sometimes ventured into metal work. The sculpture seen in this photograph is the clay model for a statue of St. Michael the Archangel that she would cast in aluminum. Alexander Giampietro (below) was another well-known sculptor on the CUA faculty. His works are in the permanent collections of the Museum of Modern Art, the Smithsonian, and the Vatican. A prominent ceramicist, Giampietro guided many generations of students at the pottery wheel. November 6, 2000, was named "Alexander Giampietro Day" in honor of his 50 years of service.

Dr. Regis Boyle received her doctorate in English literature from CUA in 1939. She taught graduate courses for teachers of journalism but is primarily remembered for the journalism institute she ran for Catholic high school students. In 1946, she approached the director of the summer session about starting the institute, and it was approved. For nearly 30 years, she ran the four-week summer program, bringing in students from all over the country. In the group from 1966 (below), Boyle can be seen at lower right. In 1975, she left CUA to accept a teaching post at the University of Maryland, and the journalism institute ended.

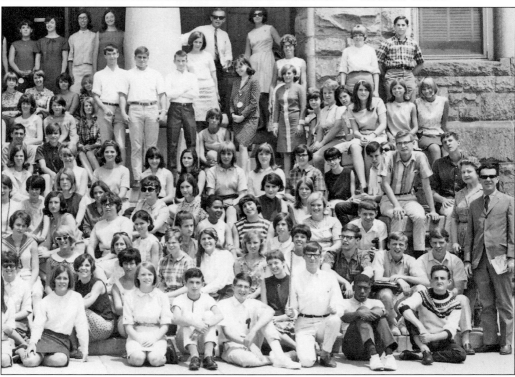

The 1960s were a turbulent time for the country and for Catholic University. In April 1967, Rev. Charles Curran, an assistant professor of moral theology, was fired by the board of trustees. No reason was publicly stated, though Curran's liberal theological views and opposition to the Vatican's teachings on contraception were assumed to be the root of the decision. The theology faculty, who had endorsed his orthodoxy and recommended a promotion, saw this as a challenge to their academic freedom. First theology students went on strike in protest, then the theology faculty, followed by the rest of the student body, and finally the entire faculty. The university was shut down for five days, making national headlines. The board resolved the immediate crisis by reinstating Curran and promoting him. But the issue was not yet settled. In 1986, the Vatican declared that Curran was "neither suitable nor eligible" to teach Catholic theology. CUA removed Curran from his post but offered him a tenured position in sociology. He declined and sued. The court subsequently determined the university had the right to dismiss him.

In 1967, ground was broken for a new theater. It was something Fr. Gilbert Hartke had been dreaming about since he formed the speech and drama department in 1937. In the photograph above, he stands at the construction site with one of his students. The dedication occurred in 1970 and presented a surprise to Hartke—the new theater would be named for him. In the photograph, below he accepts the adulation of the crowd, joined on stage by Cardinal Patrick O'Boyle, the chancellor of the university (far left); actress Helen Hayes; university president Clarence Walton; Cardinal John Krol of Philadelphia; theater critic Walter Kerr; and one of CUA's most famous alumni, Ed McMahon.

In 1966, Dr. Chieh Chien Chang, chairman of the department of space science and applied physics, created the first laboratory simulation of a tornado, using this imposing device. Smoke was introduced from below, an exhaust fan pulled it upward, then the cage itself rotated, turning the smoke into a column that spun at 1,200 revolutions per minute. Dr. Chang and his tornado machine were featured in a *Time* magazine article that year.

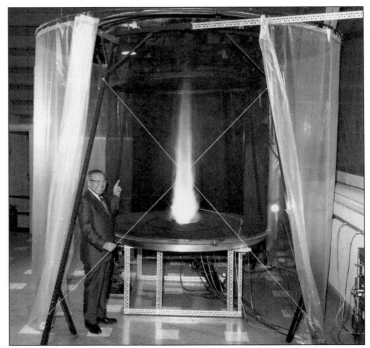

This is Clyde Cowan, who, with Frederick Reines, first discovered the neutrino in 1956, two years before he began teaching physics at Catholic University. The neutrino is an uncharged subatomic particle important in the study of cosmology and the structure of elementary particles, and its detection was groundbreaking. Cowan died in 1974, and 21 years later, Frederick Reines accepted the Nobel Prize for physics in both his and Cowan's names.

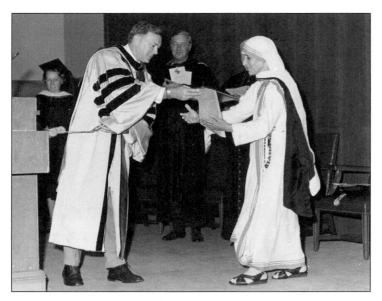

The university's first lay president was Clarence Walton. Coming from Columbia University, where he had been dean of general studies, Walton brought considerable business acumen to his position. Business ethics was one of his specialties, and he wrote a number of books on the subject. In this 1971 photograph, he presents an honorary degree of humane letters to Mother Teresa of Calcutta.

Clarence Walton did have to deal with some tumultuous events, including a 1970 student anti-war strike, shortly after the Kent State shootings. The strike did not intend to shut down the school but featured marches, rallies, and speeches against the Vietnam War. Walton had what he described as a "stormy confrontation" with student protesters at Mullen Library. Tensions were high, but there was no violence on campus.

Paul Weiss was a tiny man with an enormous mind. One of the most prominent teachers of philosophy in the 20th century, Weiss came to Catholic University in 1969, shortly after he had been forced from his position at Yale University due to his age—he was then 68. He taught metaphysics, philosophical anthropology, and the philosophy of God as well as a variety of other philosophy courses during his time at Catholic University, which stretched for more than 20 years. Weiss founded the Metaphysical Society of America and edited its journal, the *Review of Metaphysics*. He wrote over 30 books during his career, such as *Modes of Being* and *The Making of Men*, as well as popular works on the philosophy of both art and sports. When he reached age 91, the school declined to renew his contract. Weiss challenged that decision, and the university relented. He retired voluntarily two years later.

In 1976, Jude Dougherty, dean of the school of philosophy, invited Cardinal Karol Wojtyla to lecture at Caldwell Hall. Three years later, as Pope John Paul II, he returned to campus. It was the first papal visit to Catholic University. At the Shrine, the Pope greeted students, many of whom had attended an all-night prayer vigil while waiting (above). Later he went to the gym to address Catholic educators (below), saying in part: "The goals of Catholic higher education go beyond education for production, professional competence, technological and scientific competence; they aim at the ultimate destiny of the human person, at the full justice and holiness born of truth."

A new athletic center had been considered for some time before ground was broken in 1983 (with District of Columbia mayor Marion Barry and CUA president the Very Reverend William J. Byron two of the shovel-handlers). The Raymond DuFour Center is on the 40-acre north campus, about a mile from Michigan Avenue. It contains a swimming pool, gymnasium, tennis courts, and a football field, among other facilities.

Francis "Franny" Murray is a Catholic University institution. He began working in the athletic department in 1947, earned his degree in 1950, and stayed on as equipment manager. For over 60 years, Murray has been greeting students with his friendly smile and warm demeanor. In 2009, the basketball court at the DuFour Center was named in his honor.

After a new wing was added to Graduate Hall in 1959, it was renamed Cardinal Hall, and the addition served as the university social center. Within a year of this 1968 photograph, the lower level was converted into the CUA Rathskellar, which served food and beer. The "Rat" survived until the Pryzbyla Center opened in 2003.

The Edward J. Pryzbyla University Center is a very popular building, with a food court, lounges, a bookstore, and meeting rooms, including a great room that has hosted a wide variety of campus events. The building is named for a 1925 CUA graduate who is the most generous single benefactor in the history of the university. (Courtesy of the author.)

Hannan Hall is the home of the physics department and the Vitreous State Laboratory, CUA's interdisciplinary research group of chemists, physicists, and engineers. The university sent a proposal to the U.S. Congress asking for funding, and $13.9 million was allocated for the construction. It was dedicated on April 11, 1987. One of its more interesting features is the row of stainless steel air vents across the roof.

Built in 1988, Centennial Village is a residential facility that was named in honor of Catholic University's 100th anniversary. It is a collection of eight medium-rise buildings surrounding an oval lawn on a sloping hillside. It houses undergraduate students and some staff during the school year. (Courtesy of the author.)

After being squeezed into the cramped quarters of Leahy Hall for many years, the Columbus School of Law dedicated a spacious new building on October 1, 1994. With a three-story atrium and a bold, geometric design, the building is still compatible with the older campus structures in terms of scale and texture. (Courtesy of the author.)

This is Opus Hall, the newest building on campus and Catholic University's first LEED (Leadership in Energy and Environmental Design)-compliant dormitory. Seven stories tall, it houses 400 students and is located next to Flather Hall. Opus Hall was dedicated in late 2008.

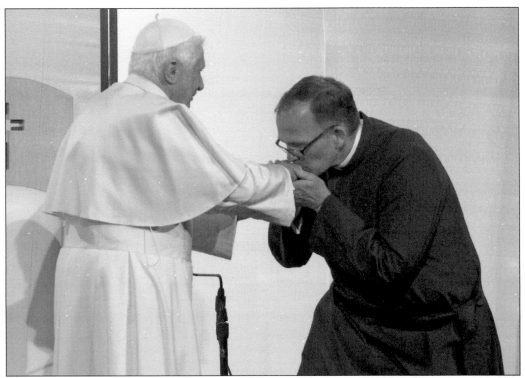

April 14, 2008, saw another papal visit, this time from Pope Benedict XVI. He was greeted warmly by university president the Very Reverend David M. O'Connell (above). At the Pryzbyla Center, Pope Benedict, like Pope John Paul II before him, spoke about Catholic education and character: "A university or school's Catholic identity is not simply a question of the number of Catholic students. It is a question of conviction—do we really believe that only in the mystery of the Word made flesh does the mystery of man truly become clear?" After the address, the thousands who had gathered on the CUA mall waited to wave goodbye (below).

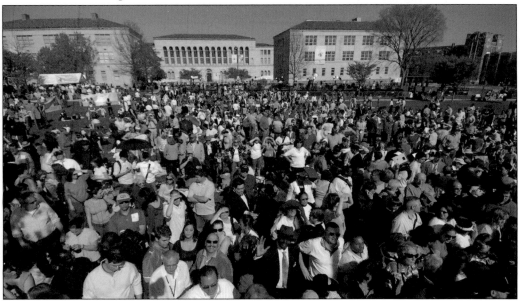

The Catholic University of America, for nearly 125 years, has striven to fulfill its mission: to discover and impart the truth through excellence in teaching and research, all in service to the Church, the nation, and the world. Today nearly 7,000 students, graduate and undergraduate, take those words to heart as they work toward educational and spiritual fulfillment. In 2007, the university ran a contest for a new tagline, a phrase that would identify CUA. The winner was senior Janelle Salamon, whose words have now become enshrined in the school's iconography: "Reason. Faith. Service."

BIBLIOGRAPHY

Ahern, Patrick Henry. *The Catholic University of America, 1887–1896: The Rectorship of John J. Keane*. Washington, D.C.: The Catholic University of America Press, 1949.

Barry, Colman J., O.S.B. *The Catholic University of America, 1903-1909: The Rectorship of Denis J. O'Connell*. Washington, D.C.: The Catholic University of America Press, 1950.

Deferrari, Roy J. *Memoirs of the Catholic University of America, 1918–1960*. Boston: Daughters of St. Paul, 1962.

Ellis, John Tracy. *The Formative Years of the Catholic University of America*. Washington, D.C.: American Catholic Historical Association, 1946.

———. *John Lancaster Spalding: First Bishop of Peoria, American Educator*. Milwaukee: Bruce Publishing Company, 1961.

Hogan, Peter E. *The Catholic University of America, 1896–1903: The Rectorship of Thomas J. Conaty*. Washington, D.C.: The Catholic University of America Press, 1949.

Keane, John J. *Keane Papers*. "Chronicles of the Catholic University of America from 1885." Unpublished manuscript.

Kuntz, Frank. *Undergraduate Days: 1904–1908, The Catholic University of America*. Washington, D.C.: The Catholic University of America Press, 1958.

McDaniel, George W., and John N. Pearce, eds. *Images of Brookland: The History and Architecture of a Washington Suburb*. Washington, D.C.: George Washington University, 1982.

Nuesse, C. Joseph. *The Catholic University of America: A Centennial History*. Washington, D.C.: The Catholic University of America Press, 1990.

Santo Pietro, Mary Jo. *Father Hartke: His Life and Legacy to the American Theater*. Washington, D.C.: The Catholic University of America Press, 2002.

Williams, Thomas David. *The Story of Antoinette Margot, a Descendant of the Huguenots*. Baltimore, MD: John Murphy Company, 1931.

www.arcadiapublishing.com

Discover books about the town where you grew up, the cities where your friends and families live, the town where your parents met, or even that retirement spot you've been dreaming about. Our Web site provides history lovers with exclusive deals, advanced notification about new titles, e-mail alerts of author events, and much more.

MADE IN THE USA

Arcadia Publishing, the leading local history publisher in the United States, is committed to making history accessible and meaningful through publishing books that celebrate and preserve the heritage of America's people and places. Consistent with our mission to preserve history on a local level, this book was printed in South Carolina on American-made paper and manufactured entirely in the United States.

This book carries the accredited Forest Stewardship Council (FSC) label and is printed on 100 percent FSC-certified paper. Products carrying the FSC label are independently certified to assure consumers that they come from forests that are managed to meet the social, economic, and ecological needs of present and future generations.

FSC
Mixed Sources
Product group from well-managed
forests and other controlled sources

Cert no. SW-COC-001530
www.fsc.org
© 1996 Forest Stewardship Council

Find Your Place in History.